Devi

Devi
Mother of My Mind

Suzanne Ironbiter

MapinLit

AN IMPRINT OF
MAPIN PUBLISHING

First published in India in 2006 by
MapinLit
An Imprint of
Mapin Publishing

Mapin Publishing Pvt. Ltd.
10B Vidyanagar Society Part I
Usmanpura, Ahmedabad 380014 India
T: 91-79-2754 5390 / 2754 5391
F: 91-79-2754 5392
E: mapin@mapinpub.com
www.mapinpub.com

ISBN: 81-88204-64-1 (Mapin)
ISBN: 1-890206-93-8 (Grantha)
ISBN 13: 978-81-88204-64-9 (Mapin)
ISBN 13: 978-1-890206-93-2 (Grantha)
LC: 2006938649

Designed by Revanta Sarabhai/
 Mapin Design Studio
Printed in India

CONTENTS

A Note on Devi's World

Indo-Tibetan psychology tells me that truth shines for a moment when my mind enters an in-between time. If I have my mind well-trained and disciplined in meditation, it stays with this clarity and keeps it in focus. Otherwise, my mind begins generating a cycle of divine energies. Further scattering generates a bewildering coil of demon energies. Finally, my attention gravitates toward a particular birth in time.

According to Indian myths, we live in the darkness and bloodiness of the Kali Yuga, the violent last phase of a dying time cycle. As our physical, technical, and cultural infrastructures break down and change, our individual and collective dramas intensify. Our work is to develop insight into the mythic drama driving our minds in time, in our histories and biographies, between illumination and destruction, clarity and chaos.

Indo-Tibetan prayers, rituals, philosophical sutras, and deity stories and images train and yoke the mind to focus toward a clear view of moral and spiritual reality and, through that focus, to be able to see things as they are in the world and in our minds. The process of clarification is slow, often repetitive with variations, sometimes with flashes of illumination, sometimes with bewildering obscuration, cycling for many lifetimes, or, in the case of this book, many rounds with temporary conclusions.

Foreword

Although She breaks life down, making hope illusory, She is also time, change, and renewal. She is the Goddess, and Her daughters, too, evolve through dread events and slowly birth new insights. Such has happened to Suzanne Ironbiter, who, since the first edition of *Devi* in 1987, has lost her husband, become increasingly alarmed by environmental degradation, and experienced the hatreds of nations after September 2001.

This timely second edition is prompted in part by Mallika Sarabhai's acclaimed dance-drama, *The Journey Inward*, based on Ironbiter's dramatic, personalized, feminized retelling of the *Devi Mahatmya*, the sixth-century Sanskrit narrative about the Goddess's exploits (Part One of *Devi* in both first and second editions). In *Durga: Demon-Slayer*, Ironbiter internalizes the Goddess's exploits, making Durga and Kali expressions of her own anger; the battle with the demon, in the second tale, is a symbolic manifestation of outrage against Mahisha, the spirit of craving. For years I have used this transformed *Devi Mahatmya* to great benefit in my undergraduate seminar, Hindu Goddesses, where students read how an ancient Indian text can inspire a modern Western woman to change. Sarabhai's theatrical rendition, first performed in December 2001 in Ahmedabad as a protest against terrorism and the dangers of othering, proves, even more forcefully, that this internalized reading can galvanize fervour across the artificial boundaries of ethnicity.

Newly added to this second edition are several new sections. *MataPita: Incarnations and Conversations*, is a refashioning from a feminine, Goddess-centred perspective, of several familiar Hindu epic stories: Sati, Siva, and Daksa; Sita, Rama, and Ravana; the Mahabharata war; and Bhagirathi's role in bringing the cleansing waters of the Ganges to earth. But unlike the personalized Durga of her earlier work, here Ironbiter's Ma, or Devi, takes birth to fight corruption, the work of her "loud children," in the external, historical world. For instance, Daksa is the smart, arrogant aggressor of today's business monopolies, Ravana the Greedy poisons the earth and rapes her minerals, and the world that cries out for the balm of Ganga, is

pierced by the sounds of saws, factories, dams, drills, and mines. Beyond this environmental focus, the Goddess also pays special attention to the needs of women, for today's Daksas continue to destroy their daughters when they stand up to them, and even Sita, Ma Incarnate, knows that she will be vulnerable to men's judgments, and disowned. In *Paravac: Secret Voice* and *Mani: The Jewel*, Ironbiter comforts herself, as it were, through the wisdom of the Goddess, who counsels her on living with and transforming her anguish at the death of her husband. In one of the most moving parts of the book, Ironbiter is told by Mother to harness her grief by learning from the sixteenth-century Rajput princess Meerabai, who sang to the Lord Krishna of the agony of her separation from him. Love in union, love in separation: tasting this oscillation is a way of experiencing Vac, the primal Voice that the famed philosopher Abhinavagupta and the grammarian Bhartrhari wrote about so many centuries ago.

Ironbiter's ultimate message is a healing rereading of Patanjali's *Yoga Sutra* II.30 and a call to vigilance in the world, while yet realizing that Ma, the Goddess, is everything against which She, the divine, Herself fights. This is wisdom indeed for our time, embedded, gem-like, in familiar stories that catch the eye by their unexpected sparkle.

Rachel Fell McDermott
Associate Professor of Asian and Middle Eastern Cultures
Barnard College, Columbia University
Author of *Mother of My Heart, Daughter of My Dreams:
Kali & Uma in the Devotional Poetry of Bengal*
Singing to the Goddess: Poems to Kali & Uma from Bengal
(Oxford University Press, 2001)

January 2004

Introduction to the First Cycle

I am full of conflicts. War follows war. There is misery,
there is arrogance. I give birth. I miscarry. I become
asthmatic. I am constrained. My sister dies. My father dies,
my mother dies. I am deep in loss. I am a taut wire. I
begin meditation. I meditate on a symbol of wholeness, one
that contains without conflict service and freedom, life and
death, light and dark, peace and anger: the Indian Goddess.

Through the practice of meditation, I observe my patterns
of quiet and disquiet. A continuous pulse and respiration, a vital
rhythm, sustains a fluctuating interior. My old knots and self-
conflicts relax bit by bit. I am more centred, more grounded in my
body on earth.

I want to develop an epic-like universe, based on the
personal human form, which can provide a narrative setting for
my meditative journey, a poetic space in which mythical, mystical,
and philosophical dramas can take place. I want to express my
experience that an indwelling Goddess and introspected body have
a mythopoetic validity, an imaginative intensity and interpersonal
coherence, with gestative and nurturing powers balancing and
complementing the powers of a transcendentally imagined God
and object bodies.

Drawing from my studies in History of Religions, I
compose poems based on Goddess myths. I find in Indian cultures
fecund layers continuously alive from prehistoric, stone age, and
ancient times. There is a wonderful mixing of the primitive and
sophisticated, the earthy and the sublime, the low and the high, the
obscure and the luminous.

India's warrior goddess epic *Devi Mahatmya*, Song to the
Great Mother, becomes the basis and model for Devi's first section,
Durga: Demonslaying. After *Durga* there follows *Prajna: Discourses
on Wisdom,* wherein I journey back and forth between maximalist
Hindu and minimalist Buddhist ways of interpreting and shaping
meditative experience. In a third section, *Shakti: Power Rises,*

I imaginatively undergo secret tantric rites of the Goddess as inner energy rising and interacting with her male half. These three sections form the first edition of *Devi*, completed in 1984, published by Yuganta Press in 1987.

In this new 2004 version, expanded with a Second Cycle of poems, some lines of the first edition are changed to ring true to my memory of then and my present awareness.

Readers who wish to find out more about the Indian sources and their contexts may refer to the Appendix at the end of the book.

DURGA
Demonslaying

I. Goddess Hard-to-Reach Slays Demons Madhu and Kaitabha

There are wars in the minds of men,
there are wars in the mind of Man.
This is that story.

It begins deep inside.
Words follow words.
I can't find the meaning.

I give my daughters food.
I smooth their beds.
Why are they growing?

Is there a goddess in us
who is the way we are,
fast, slow, repeating?

I reach the end of a time.
Childbirth is gone.
Parents are gone.
I fall in the sleep that comes between times.
I surface a while.
People are talking. I am among them.
The sound of our voices, the stuff of our bodies,
are waves passing through us.

While my mind stays clear,
the waves are easy.
Then I drift away.

My world is dark water. I am stretched in sleep
on the long couch of my body.

I am reading a palm book, *Mahatmyam,*

something I read when I am sleeping.

It tells of the devi Durga, Hard-to-Reach,
who comes from within in times of trouble.
It is a hard time, I say. Tell me. Help me.

There are wars, I hear, between life and death,
and a goddess who wins life.
There are armies of killers that roar in the dust of the ears,
and a goddess who kills them.
Taking violent forms, she rides on the back of a lion.
She gives power to the weak ones.
Give me power, I say, I am tired of being exhausted.

The black goddess, Mahakali, dark mother,
Chandika, red-fanged killer, burning with anger,
a thousand goddesses, all women,
taking infinite forms,
always one power: picture this one.

The wars begin in the watery age, before earth was.
I am there in the dark waves.
I sleep in a place where life is beginning.
Two sunless things, insinuating demons,
squirm in my ear-dusts:
Madhu, named of honey; Kaitabha, named of worms.
They want to kill the Breath who keeps me being.

A lotus floats from my navel on still water;
Breath sits sleepless on its centre.

Seeing the bad spirits, Breath begins to sing.
He addresses my darkness, the place where my sleep is:

"You Mahakali, Dark Mother,
you who have ten faces,

ten ways of seeing and appearing, ten ways of standing,
ten ways of holding on,
three eyes, a dark blue radiance,
draw yourself out of this body you have put to sleep here.

"You Mahakali who are the cause of things beginning,
you who sustain them in their being,
and when they are destroyed you have destroyed them,
you Mahakali who are always as things are and happen,
good and evil, holy and terrible, truthful and deceiving,
draw yourself from this body you have put to sleep here,
come out in black radiance from every pore.
For these ones, Sweet-spirit, Worm-spirit, seek to kill
the will to live where life is beginning."

My Darkness, Mahakali, crawls from my body.
I am real to me now and what I see is real.
I see the two demons, their mould-rimmed eyes,
their ashen skin, pale lips,
reptilian cold, breath of acid.
I fight them down 5000 years. (That was all in the days
when the world was water.) Worm-spirit says slyly,
"Kill us on the spot where the earth is dry."
I raise my loins out of the water.
Standing the demons on the land my thighs form,
I cut their heads away.

So Breath awakes my Darkness
and saves himself from being killed
in the watery age
by the demons inside me.
This is the first war.

II. Chandika: Her Anger Slays Demon Mahisha's Armies

There is no end to the war in Man's spirit.
The One who Breathes keeps watch
for the armies of demons that roar in the dust of the ears.
Again and again, the devi comes out
and takes on a new form to destroy them.

It is the second war now,
a time of drought, fire, and volcanoes.
In the place where man is begun, he is bull-headed.
I am restless in that place. This is what I see.

Mahishasura, a man with a buffalo head,
a mighty demon, a spirit of mindless craving,
has sent the stars to earth.
Cosmos and Sun, Fire, Air, Moon, Void, bright Thunder
and all the shining planets lose their powers.
Mahishasura's dense breaths have cloaked the sky.
No one escapes their poison.

I sit in my house with the comforts of my reason,
my daughters beside me, my table full.
Every day I cleanse my ears
and disperse the bad things in the out-breaths.
The fallen lights come near to my windows.
Shelter us, they say. Destroy our enemy.
Mahishasura, spirit of craving,
rules the great expanses of the sky,
while we, the points of light,
the source of all men's hope and promise,
lie vanquished.
Be angry.
Make, from the substance of your anger,
someone to help us.

Out of my face comes light in the form of a woman.
This is the substance of my anger:
sorrow for the breadless, sorrow for the children.
The lights of the stars and open spaces
accept this substance of sorrow.
They clothe it with face and arms,
the Moon gives full breasts,
the Thunder gives buxom thighs,
Earth gives rich hips, Cosmos her circling waist,
Void gives dark hair,
Sun gives flashing toes,
Planets her fingers, Wealth her long nose,
Air her ears, Fire three flashing eyes.
She sits on a lion ruddy as flame,
the gift of Himavat, the snow-clad mountain.
Her skin is red, the colour of coral.
Eighteen hands hold tools for fighting.
She is covered with jewels from the milk of the ocean.
From the wealth of the earth she holds
intoxicating flowers and a cup of blood wine.
Great is her roar, the swell of her violence.
Ready for battle, eager to kill,
her roaring fills the sky.
She rides forth, glorious, the lion-rider.
The world shakes at her steps, the seas tremble.

Mahishasura rushes at the roaring.
He sees the bright red one, arms now a thousand.
Her headdress scrapes the sky, her steps bend earth.
At the sway of her hips the shaking goes
through the crust to the core.

Mahishasura calls up his generals, Chiksura and Chamara, second
 in command.
Chiksura marches out from the roots of my hair.
Over the left ear, chariots and horse,

from the right, foot-soldiers and elephants
assemble by thousands,
multiplying, as hair grows, into millions.
They bristle across the field
at the feet of Chandika, the face of my anger.
Chamara comes from the tufts of the tail,
fossil in bones at the base of the spine;
from each strand, lacs and crores,
horses and elephants, chariots and men,
doubling Chikshura's charge.
From the points of the moustache and beard,
wrapped up and behind the ears,
Udagra and his hosts, flanking the field,
and Asiloman's host, from the hairs of the arm-pits,
each man like a sword.
(Others also, more than I can tell,
Karala from the teeth, Bidala from the nails:
uncountable and terrible the powers without feeling
that grow from the places unseen,
each from a single cell, under the skin.)

Chandika sits on her lion
like a wind on a fire in the forest of her foes.
Her arms whirl out
in their hundreds of thousands.
She liberates her war-delight with the roar of a million.
Her deep powers bellow. Between Her loins Her lion thunders.
Her issuing airs peal with the sounds of conches, trumpets, and
 drums,
her heart and her lungs, the noises inside her, made huge in her
 focus.
The charge of the generals' hosts touches her power with the
 strength of feathers.
Her breath cuts off man after man, troop after troop.
The larger their onslaught, the denser the spin of power from lion
 and rider.

They on every side, she in the centre:
they are wounded and rise in their pieces,
again and again they charge the shield of her roaring.
Her weapons spin with her arms, smashing, lopping, piercing.
Blood covers the fields.
Horses and legions lie in piles of heads and hands and hooves,
their trunks still rising, unable, yet furious, to war.
Chandika's lion prowls where they lie,
seeking the last vital breaths, and snorts them away.
The legions are scorched, a field of dead grass.
The generals remain.

III. Chandika: Her Outrage Slays Mahishasura

The generals watch the defeat of their men
and their fury grows on them.
Now is their time to attack, each in his turn.
Chikshura comes first, riding a chariot, raising his bow,
showering Chandika with arrows.
She with her strong out-breath
turns his weapons back on him.
He falls like a porcupine, all sides bristling.
Now Chamara, armed with a spear and a pike,
mounts a great elephant. Chandika's lion leaps
and clings to the elephant's brow.
Chamara flings out his pike.
Chandika hurls out her pike in return;
meeting in mid-air, they fall into fragments.
Now the lion with a blow from his paw
crushes down Chamara's head
till it finds out his bowels.
Udagra next falls from a stone expelled
by the glance of the goddess' eye.
Asiloman, when he charges, is ground to a dust
by the blows of her arms as they spin
on the wheel of her breathing.
Karala, Bidala fall
to the pummel of fists in the swing of her arms.

Now Mahishasura, standing alone,
musters his magic.
He takes on his buffalo form.
He bellows, he stomps with his raging hooves,
he wheels round the field at the speed of a comet.
Breath blasting, he uproots the earth with his horns,
he punctures the clouds, his tail lashes the sea.

Chandika watches the crazed buffalo wheeling around her.
He lays waste the earth up to the place
where the pads of her feet stop his fire.
(In the lines of her footprints life crouches in shelter;
the sun comes and goes under there in the blush of her toes.)
He rages year after year. The earth is ground down;
the debris of his ravagement, the stench of his breath close the
 sky in.

When the world is undone,
Mahishasura stands to fight Chandika.
She takes up her wine-cup and drinks her eyes red.
Her skin which was coral now shows rage-red, violent, flaming.
She flings out her noose round his neck,
but he slips from his buffalo form.
He becomes a great ape, then a man.
She undoes these forms also.
Next as an elephant he charges her lion.
She severs his trunk with her sword.
Returned to his buffalo form,
he shakes the whole world to the top of the sky.
She jumps up and lands on his neck with her foot.
Caught under her heel, Mahishasura
half comes forth in his actual form
from his buffalo mouth.
His head falls off to the goddess' sword.

So Chandika, my Outrage, slays
Mahishasura, the spirit of mindless craving
who rises from my wastes
in the days when the world is laid low under poisoned sky.
This is the second war.

IV. Prayer to the Goddess

When the war is over
and the mighty Mahishasura is overthrown,
the star-bodies quicken with horripilation.
They leap with joy. Their lights cleanse the air.
The world shines on all its surfaces
like one new-born.

The stars sing Chandika their prayer:

"Give, O Chandika, your mind
to protecting this world,
to tending the house of Man.
Destroy in him the fear of evil,
a fear that dulls his powers.
His tense, wrinkled vision
makes our light sicken.

"We offer flowers of Nandana, heaven's garden,
incense, Kasturi, Chandana, Kaipura,
musk, sandal, camphor,
and perfumes, jasmine, patchouli, rose.

"Protect all living things
with the power of your generous hand.
Nothing can deter it.

"Give Man wholeness of mind.
May he look on your radiant face,
red-orange like the rising moon,
and know that you love him.

"He lies like a baby on his cradle, Earth
where you have placed him.

He does not understand his little body,
or how to suck your luminous milk
from the breast of the air.
He does not know the sense of your singing,
the sound of breath and heartbeat, hum and drone.

"Stroke the rounding of his head,
caress his hands and chubby limbs,
massage the strange soft organs through his skin,
your fingers dipped in earth and moonlight,
the oil you mix with a drop of burning
to polish human beauty.

"See how he tries to eat the world.
Things go against his wishes, and he cries.
He does not like to be alone.
There are sounds outside the doors
he does not want to hear.

"He does not understand that he is you.

"You alone can show him your true nature,
bloody and radiant. What can describe it?
He must feel it within him,
where the bowels touch the heart.
Grant this to us."

Then the goddess Chandika, hearing these words,
smiling on the stars, says,
"Be it so!"
and returns through the light of my face
to the place within.

V. Bad Shumbha Sends His Wooer to Durga's Woman Form Ambika

After Mahishasura is killed
for more than a thousand years
the demons in the ears of Man
have no great rulers to direct their powers.
The stars keep their place in the skies.
The cosmos goes its way.

After a time, and a time,
a pair of bad ones,
Shumbha and Nishumbha, his young brother,
drinking the blood of bulls, grow strong and lusty.
They ravish the house of Life and the house of Death,
stealing Life's chariot, yoked with swans,
and Utkrantida, the tool Death has devised
to suck away the powers of earthly beings.
They take the world's treasure of flowers, jewels, gold,
elephants, and all rare things.

I, Ambika, watch the looting begin from my cave in the mountains.
I sit on Earth's peak and give light,
a moon at the fringe of a cloud.
My hair is the ice of the streams,
my body the smoke-dark stone mantled in snow.
I am the Glacier of Mind, high source
of the Consciousness Rivers and Streams,
wide in the valleys, flowing to Ocean,
where men as they bathe
are swallowed in me.

Now I slip from the shape of the mountain.
Dressed in Woman's form,
I bathe in the waters of Ganga.

My body is dark; my sinews ripple and shine
with the strength of a cobra, the sheen of a panther.

As I bathe, Chanda and Munda, servants of Shumbha,
admire my beauty.
They run to their master:
"O King who possesses the wealth of the world,
one treasure, a woman,
is not yours. How can this be?"

Shumbha calls up his messenger Sugriva:
"Go to this woman. Say,
he who possesses all the wealth of the world
desires you also.
See that she comes to me."

Sugriva runs to Ganga.
My limbs and breasts and hair are alive in the rush of the waters.
He speaks to me sweetly:
"O Goddess, Shumbha, King of Demons, World-Ruler, sends me.
Listen to what he has said.
No one resists his command.
He says, 'Everything is mine—the things of the sky, of the earth,
and the things under the earth.
Whatever rare thing, star, death, or living being has ever held
is now with me.
You are the rarest of women.
Come to me, since I alone enjoy the wealth of the world.'"

I grow serene and silent in the waters.
This is what I say to Sugriva:

"All this is true. Indeed, Shumbha rules
below, on earth, and in the sky.
But how can I make false what I have promised?
Hear what promise I have made, and I dare not break it:

"Who conquers me in battle takes my pride,
who is my match in strength shall be my husband.

"So let Shumbha come, with great Nishumbha.
When one has vanquished me, then I will love him."

Sugriva cannot believe I have denied him:
"Do not be haughty.
All the world cannot defeat the demons in battle.
What man would dare to stand against King Shumbha?
How can you, a single woman, face him?
You should go to him.
Let it not be that everyone will see
him conquer you and drag you by your hair."

"What can I do?" I say. "My vow is old.
Tell Shumbha what I said.
Let him do what he considers right."

VI. Ambika Slays Shumbha's Chief Dhumralochana

Sugriva returns to Shumbha.
The king does not care for my answer.
He calls the chieftain Dhumralochana, Red-Purple Eyes:
"You, Dhumralochana, go with your army.
Cast that shrew to the ground
and drag her by the hair.
Slay anyone who tries to save her."

I am sitting on my snowy mountain.
The chieftain approaches me and says:
"Come to the presence of King Shumbha.
If you refuse to go with pleasure now,
I will take you by hard force and drag you to him.
He will put his foot upon your head
when you are cowed."

I see his many thousand demons forming in their armies.
I say:
"Shumbha is mighty, you are mighty.
If you take me by force, what can I do?"

Dhumralochana attacks with fury.
I sing my contempt for him
volcano's roar, groan of avalanche, flood-bellow,
"*HUM-HUM*."
The sound alone reduces him to panic.
His mind collapses like a mound of ashes.
His army sticks in the sludge of his deposit.
They try to throw their javelins and axes.
My lion wakes up from his sleep in my cave.
As they raise their arms, he leaps out upon them.
He tears away their arms and pulls off their heads.
He drinks the blood from their hearts

and roars for more blood.
But he has killed them all.

When Shumbha hears how I have slain his chieftain,
how my lion ate up all his army,
his lip quivers with anger.
He commands his henchmen, Chanda and Munda:
"Bring her here. Wound her if you must, and kill her lion.
You can see that she is dangerous and must be bound."

VII. Kali: Her Blackness Slays Shumbha's Servants

My lion curls up by my cave in the mountains.
I sit on his haunches, watching the world.
Chanda and Munda see me from afar.
I am golden and large, a sun on my lion.
I freshen the heat of my breasts
with sandal and camphor. My hip girdle glows,
hung heavy with topaz and diamond.
I excite the legions of Chanda and Munda.
They think they will take me.
As they approach, my radiance burns vivid with anger.
The warmth of my veins turns to char,
the light of my gaze to a green-black vapour.
I contract my brows in a frown. In the flat of my forehead
a gaping grows with my scowl.
Kali, my Blackness,
steps from my head, from the cranial pit,
great hole of my anger—Kali Karalavadana,
my Blackness whose mouth is a hole, raw as a wound,
whose tongue is a cleaving sword,
and the world at her feet is a world drained of light,
gashed open and bleeding.

My Kali comes down from the crest of the mountain.
Her bones protrude through her flesh.
Strung skulls clack on her slackened breasts.
A fanged tiger-skin flaps on her dried-up haunch.
Her eyes are dull red, two coals sunk in darkness.
Her tongue lolls out, side to side, loose as a tail,
coursing the ground.
Her heads are two and then three,
her tongues spin around, lashing the legions before her,
throwing the fighters and mounts;
chariots, horses, and elephants vanish

into her mouth, down to the pit of her darkness,
some swallowed whole,
some with the black stumps of her teeth
crushed into fragments, some ground under foot,
some flung by their hair
and caught in her mouth in mid-air.
All are devoured.

At the loss of their army,
Chanda and Munda attack in a fury.
One showers my Kali with darts by the thousand,
one hurls his discuses, filling the sky.
None hit. All disappear into the mouth of my Kali.
She roars with her gorging. Her two fangs gleam,
their blades are the skewers of men-flesh.
Foam spills from her lips; gobbets of meat, blood-wine
mix in a belch with the sound of her scorn.

In love with terror, Chanda and Munda rush at my Kali.
Taking each by his hair,
she strikes off their heads with a slash of her tongues.
Swinging those heads on the slings of their hair,
my Kali rejoices before me:
"Here are the heads of your foes!"
"Thank you," I say. "I shall call you skin-bag,
Chamunda, all-eater, stomach-body."

VIII. Kali and Seven Mothers Slay Red-Semen Shumbha's Champion

Shumbha gets word of his losses.
He calls up the whole of his kingdom to join in the battle.
There are eighty-four families, heirs of old Kambu,
and their forces, seed-demons
in the shape of spirals and tubes;
fifty Kotivirya, hooked semen-spirits;
one hundred Maurya, ring-circling germens;
all the black legions of Kalakas, Dhaumras, Kalikeyas;
the Daurhidas, with their insides misshapen.
Shumbha goes forth with his thousands of thousands,
and with him his champion Raktabija, Red-Semen,
Pomegranate, from whose blood arises, for every drop,
like seed when spilled, a thing mighty as he.

My Kali, my lion, and I are tuned for the violence.
I twang on the serpent Vasuki, my bow-string.
I bellow out breakers of sound in the air sea.
The clang of my war-bell, the roar of my lion
gladden my Kali. She opens her mouth wide.
She swallows the furious noises of Shumbha's attack
with the surge of her *HUM*, enraging the legions.
We at the centre, they all around us
stand poised for the battle.

The Seven Mothers,
my handmaids in war, come forth
from the seats where my power lies:
Aindri, formed from the moon of my womb-power,
rides Gajaraja, king of the elephants
(her weapon is vajra, wild thunder,
she sees with the eyes of my eggs, thousands on thousands);
there are three from the fire of my belly—

Vaishnavi, riding Garuda, the bird-chief,
Narasimhi, the lioness, Varahi, the great-snouted sow;
out steps Kumari, the virgin I reared
in the cave of my heart (she rides a fine peacock);
Maheshvari, from the seat of day-seeing and night-vision,
is armed with a trident, striding a bull;
Brahmani, carrying prayer beads and water jar,
springs from the small life-hole at the top of my skull.

Aroused by the roar of the Mothers,
my husband the sleeper, Svayambhu the Self-Born, Benign One,
 Destroyer,
awakes in his cave on the mountain Kailasa.
He says, "Let the enemies be devoured!"
At his words, the power of my wholeness comes forth,
hundreds of jackals, all the strength of my howlings.

Now I say to my husband:
"Go into the presence of Shumbha. Tell him,
'Yours is the underworld. Only there may you live.
Leave me my mountain.
Return what you stole
to the house of Life and the house of Death.
Give back what you owe Earth.
But if through pride in your numbers
you hope to undo me,
come see if my jackals are hungry.'"

Shumbha and his armies do not like my words.
They answer with arrows, axes, javelins, spears, and every weapon.
I cleave their missiles in mid-air.
Beside my armaments, theirs are like toothpicks.
Brahmani sprinkles the men with drops from her jar.
Their manhood shrivels.
Maheshvari, Vaishnavi, Kumari, Aindri
tear with their weapons the warriors by hundreds.

The Sow with her snout and tusks,
the Lioness with her claws
rip up flanks and shoulders. What they cannot devour,
my Kali licks up with a flick of her tongue.
Seeing the fierce band of Mothers ruin his army,
Shumbha's manly champion Raktabija
strides forth, club in hand.
Aindri strikes him first on the loin with wild thunder.
Blood flows from his wound;
from each drop springs forth a new fighter.
Vaishnavi, Kumari, Maheshvari, Varahi
strike with thunder, discus, sword, and trident.
Still from his blood, from the endless wounds,
new legions arise, mighty as he.
The spirits that are born from the blood of Raktabija
soon fill up the world.

I say to my Kali:
"O Chamunda, all-eater, stomach-body,
open out your mouth,
take in the drops of blood as I strike Raktabija,
and also the fighters they bear.
Roam over the field.
Eat up the hordes sprung from him.
Then when his blood has been drained,
no more will be born."

I strike that Pomegranate with my dart.
My Kali laps up his blood.
He strikes with his club;
it touches me like cotton.
I smite him with arrows, swords and spears.
Chamunda drinks the blood away.
Bloodless he falls to the ground,
a hollow white pulp, crumpled and dry.

So I with my Seven Great Mothers
kill King Shumbha's hosts
and Raktabija, mighty champion.
How we dance after that, black flames on a ruby field,
with the thrill of our gorging.

IX. Kali and Her Lion Slay Shumbha's Brother

Now I will tell you how King Shumbha behaves
after I have killed his champion.
He and his brother Nishumbha rumble with wrath.
The muscles in their jaws and bellies clench
drawing their skin back tight;
their eyes and nipples bulge like hot boils.
They bite their lips, tug their hair, and tear
against the skin around their nails.
They scream and moan and cannot speak for madness.

Nishumbha charges around.
He and Shumbha call up the last of their legions.
They come at my flanks
showering arrows and spears. I split their weapons
with mightier discus and arrow.
Nishumbha strikes at my lion:
I shatter his sword and his shield.
Weapon for weapon, I overpower the great Nishumbha.
He faints to the ground.

Now Shumbha, enraged, stands up in his chariot.
He has eight long arms; they shoot out like lightning.
He shines like a blast through the crest of the sky.
The earth melts at the heat of his coming.
Kali in her glee springs up in the sky,
hurtles down to the ground, lands on her hands,
and flips up before him.
The noise of her bounding and laughter
fuels the wrath-roar in King Shumbha.
I say to him, "Will you not stop, Duratman,
evil spirit, will you not stop?"
My husband says to me, "Now be victorious!"

Shumbha hurls his spear, a mass of wild fire.
It bursts through the air-zone circling the world,
spraying shards of combustion.
I shoot out my fire-brand greater than his
and smother his burning.
When he picks up his bow, I split his hot arrows
and he splits mine.
I raise my trident and strike
till he faints to the ground.

Nishumbha recovers.
He stands very handsome and proud.
He gathers his weapons and puts forth a wheel of arms
hurling discus and arrow, which I split with my missiles.
He attacks with his club, determined to slay me.
I cut through his club with my sword. He takes up a dart.
He advances; I strike my dart through his chest.
Out of the pierced heart comes a new man,
handsome like Nishumbha.
He says to me, "Stop."
But I cut off his head and he falls to the ground.

My lion and my Kali eat up the hosts of Nishumbha.
Also Kumari, Maheshvari, Vaishnavi, Aindri
cut up and kill Shumbha's men till he lies there alone.

X. Durga Slays Bad King Shumbha

Shumbha, awaking, laments
the death of Nishumbha, whom he loved.
"O Durga," he says,
"you are puffed with your pride.
But your strength stands upon the strength of others.
Fight me alone, hand to hand in close contact,
without your handmaids."

I say:
"One life only am I here.
Who stands external to myself as my companion?
See, Dushta, evil king,
all these are my own powers.
I have projected them. I re-absorb them.
In their many forms my powers deceived you.
Now I stand alone.
Let us test our strength in single combat.
Let us display our might, and find the victor."

Myself and Shumbha stand astride the hemispheres
displaying our tools of combat. Missiles, counter-missiles
we discharge in thousands.
I playfully break up his arrows and his bow,
his discus and spear
with the shout of my *HUM*.
His sword shines bright like the sun,
on his shield are one hundred moons.
I split all these.
I shoot down his horses, fell his charioteer.
Raising his fist, running like wind, he rushes upon me.
He brings down his fist on my heart.
I strike back with the flat of my palm on his chest.
He falls down, rebounds, grabs me up by the waist,

mounts high in the sky.
There we, without ground or support, fight on
in close contact, rage-fires wrestling through the air.
Year after year we are locked in our contest.
We create a floor to the sky
from the clouds of our anger.

At last I feel in his left thigh a weakening.
Taking him by the waist, I whirl him above me,
fling him down to the earth below.
He rebounds and attacks with his fists.
I can see he has lost all thought from his mind
but the one thought of killing.
I focus my powers to the point of a dart
and puncture his chest.
His life flows out from the hole in his heart.
When he falls to the ground, the earth shakes,
islands and mountains.

Suddenly the air of the world is clear.
The universe, stretching on every side, is still and joyful.
There is the sound of peace from the depths of the earth
where the roots of living rub like fingers on zithers of stone.
Bright rivers and seas run smooth in their courses.
Wild flames return to their place underground.
The world displays its splendour of treasure,
flowers, animals, jewels.
The sacred fires in the house of Life and the house of Death
are brilliant and tranquil.
Between the creatures of the earth and the stars,
song answers song.

XI. Song to the Mother of the World

Now the stars flush with joy
from their toes to their cheeks
throughout deep space.
In their choral rows,
they mirror the earth's people. All sing praises:

"Goddess, Matarjagat,
Mother of People, Mother of the World,
Mother of dead ones and live ones,
having won out in three great wars in the hearts of men
between demons and stars,
you are Goddess of All.

"Mother of Earth,
support us,
make the world of living creatures one.

"Sea Mother,
be around us,
move us, rest us.

"Mother of Life,
breathe in us,
beat in us.
Draw forth our powers to touch and smell and taste,
to see and hear you.
Show us the ways to know you.
Let us touch your heart.

"Mother of Knowledge,
you make our life a crystal form
displaying your aspects.
It is dark by day and clear in dream-light.

"Mother of Visions,
in your three-stranded braid, in your three eyes,
in your mighty trident prongs
you create, sustain, destroy us,
you destroy, sustain, create us.

"We cling to you, giver of refuge, constant shelter,
only companion in our sufferings,
the only one who goes with us to death.

"Your forms are endless—
Brahmani, Maheshvari, Kumari, Vaishnavi, Aindri,
Chamunda, Durga, Chandika, Ambika—
endless your names, your weapons, mounts, and jewels,
yet each one moves in us
and gives us power.

"May your sword,
smeared with the blood and fat of our fallen demons,
your great light gleaming in its magic steel,
be sharp for us.

"Age after age, the evils in us rise against us,
and we who were healthy grow sick and feeble.
We fear the wars to come. We call on you, Goddess.
Save us from the powers that destroy us."

XII. The Goddess' Promise

The Goddess answers the prayer of the people and the stars:

"When the twenty-eighth age has arrived
two demons born of bad thought
will seek to divide the earth from the sky.
I will come again then, a woman born of a woman's womb,
and I will eat those bad ones.
My teeth will be red like the pomegranate flower,
and you will call me Red-Tooth, Raktadantika.

"And when the rains have failed for one hundred years,
I will come as Shakambhari, Vegetable Food,
one hundred-eyed,
bearing unearthly herbs,
and I will feed the world till the drought is gone.

"Again in an age and an age, when a great hot demon,
Aruna, shall arise,
I will take on the form of a wild bee horde, Bhramari,
and with my whirling stings extinguish him.

"Where the fields are rich in grain,
the children shine with health and vigour,
and man and wife are brave and strong together;
where children are bred carefully in comfort,
and every side of life is bright;
where a man sits long alone and in despair
outside of nature;
where a woman, torn against herself, walks
into the sea:
whether for gratitude or for petition,
remember me.

"When you pray to me with concentrated mind,
your troubles will be to me as Madhu and Kaitabha,
Mahishasura, Shumbha, and all their hosts.
I will meet them in set battle.
Though they are strong,
matched against my powers, from which all powers derive,
they will be destroyed.

"When you, of single mind and with devotion,
hear this *Mahatmyam*
on the eighth, fourteenth, and ninth days,
no calamities will come from your wrong-doings,
you will not starve, your errors will dwindle,
you fears will cease.

"My sanctuary is where I am remembered.
I will never forsake that place.
There my presence is certain.

"Unfavourable influence of planets, bad dreams,
fits of children, splits in friendship,
demons, goblins, ogres, robbers, beasts,
enemies of every kind, storm, prison, pain,
wasting —remembering me, you need fear none of these.

"Your fears are like the spirits that shout
and whirl their arms
and bellow out the anger of their weakness.
When you remember me,
they meet me face to face, and are destroyed.

"In your heart is the matrix of your being,
vaster than the universe of stars
lighting you toward radiance,
vaster than the great cities below
the surface of your mind

where the spirits of every age are housed,
and the bad among them work for your destruction,
vaster than the world of earth and seas,
societies and families.
Like a mesh in the sea,
the three worlds, heaven, earth, and hell,
slip through me,
are soaked with me,
yet they hold nothing.
If you remember me,
I hold you."

So speaking, the Goddess takes away
Ambika, her Woman form
which had seduced King Shumbha,
and goes to her placeless place
beyond the forms of incarnation and creation,
beyond delusion, knowledge, fortune, and destruction,
beyond sustenance, beyond protection.
There she waits for worship.

XIII. Uma's Boon

I in myself worship her with flowers and incense,
fire and libations.
I in myself abstain from drink and food.
I concentrate my mind.
I offer the blood from my body.
After three years, Ambika appears.
"There are two of me," I say.
"One seeks earth-household, health, beauty, and kindness,
love after death.
One seeks dispassion and detachment, the knowledge
that removes the veil of *I* and *mine*."

Ambika replies:
"Know me as Uma, that is, 'oh not…,'
for when I would give up the comforts of life
for my lover Svayambhu,
I said, '*U ma*, and not
without pleasures should you serve
Svayambhu.
He is the child of Woman and needs love.'
Therefore, by attachment to much, one weds
the I's destruction.

"You have seen my Mahakali, my Chandika, my Kali,
my anger and my darkness,
how they have come and gone.
But in the forms of Knowledge and Good Fortune,
Sarasvati and Lakshmi,
I stay in you.
More sure than swords,
these things, shared feasting, display, affection,
destroy the evil demons of the heart,
self, pride, and sick desire.
Therefore I grant you pleasure."

Having granted the boon that we desire,
the Goddess disappears.

As a result of her favour, I shall obtain
a new birth through the moon,
and shall be the eighth Mother,
Savarna, having the same color,
the Mother Savarna, *KLIM OM*.

PRAJNA
Discourses on Wisdom

I. Rafts in the River

I wait for the good times.
I float on the dark water.
Shall I drown or return where I came from?
There is nowhere to cross to.

My heart-beats and breaths form a raft.
My two minds sit on them.
I hear *MU* in one thought,
empty womb, prayer for no being.
Below *MU* I hear *OM*,
thought of bliss, sounding full being.

Now on the chord of these two
I have gone past the middle.
Now I've lost where I came from.
I am frightened by currents and high waves.
I begin to hear Prajna, my Grandmother,
Wisdom, Self-Knower,
call from a land far away where the waves go.
With the wand of her fingers she draws me on toward her.
How lovely she stands
in her circle of yakshi-yoginis, earth-spirits,
runners born from the feet of her consort,
Creator, lost Grandfather.

"Tell me, Grandmother, what do I do now?
How can my heart-beat and breath
bear both empty and full sounds
and travel through all the hard waves to you?"

"Your blankness will cleanse you.
Bliss will come out from the fullness of your life and surround you.
Follow the moon, the waters, the womb song.

Leave the bright heavens, the stars and the hot sun.
Always by turns I flow in, then shrink from you.
This is part of the changing that being is.

"You have stuff in your mind from your living.
You bury the heavier stuff that has come from your dying.
This makes you two layers.
You ask yourself which is the real one.
You begin thinking, perhaps you are two ones.

"A split mind is torn from itself in the day's tides.
It moves mostly upwards and downwards
and cannot go on or beyond.
I am neither above nor beyond you, beneath nor behind you."

Suddenly on the dark river where I am floundering
Prajna's own raft appears right beside me.
All around her, her yakshis like ferry-girls row her.
She sits me beside her. She tells me:
"I have taken you up from the river
to sit here and watch change." I say:

"I am restless from being in these waters.
I can't sit still and watch motion.
My minds are too nervous."

"Stay by me and sit at my feet here.
I will teach you to be still and watch change.
Your mind contains powers
with their centres all moving, revolving,
each at its odd speed. Only the slowest, from inside,
can see all the fast ones.
Therefore, to listen, stop struggling,
sit still and do not move."

My Grandmother Prajna sits as still as a large stone.

Her yakshis move with the winds and the waters;
their splendid curves are strong stone, but bending.
As a parasol, lotus, or swan's wings
their rhythm surrounds me.
I sit near their heart or their navel,
Trying to be quiet.

II. The First Instruction: You Are Not Real

"You are not here, Ironbiter," says Prajna.
"You have imagined this raft and these magical spirits.
There is no river.
What goes on in your mind goes on just in your mind.
There is no here there.

"Without magic and raft in your mind
you, being unreal, would be tossed in the fictional river
for as long as your mind can imagine
the length of forever.

"Even the facts from outside of your mind
become phantoms inside you.
All the world that you know
is the world in your mind.

"Your organs, your channels and fluids,
your shape and what you do—
these are all real things.
But your mind, all-consuming,
changes these parts of yourself,
when they come to be known, into mind-things.

"When others perceive you, you, of real flesh and deed,
turn, in them, into fictions.
No Being past the ten million worlds
holds each you as a fact in his mind
and keeps you stable.

"Do not, upset that you are nothing, injure a real thing.
From an error in your thought, you may suppose,
about pain, that it's nothing.
The pains in yourself and the world are, in fact, pains.

"Do not take time to lament, for lament is illusion.
All you can know that is true is the way to stop pain.

"Learn the beginning of pain-cure:
the subject who suffers the pain is illusion.
He has made himself up as a fiction.
All self is in fancy.
Only the self, itself unreal, knows the real things,
and all that is known becomes, in the mind, as nothing.

"Therefore why should you act on the panic
that lives in the shadows of mind
without substance? Sit still. Float
on the waves of the unreal.

"Altogether beyond river and mind
my wisdom, SVAHA."

Having completed her first instruction,
Prajna sits like a mute stone.
Her yakshis bend and sway in the wind
like strong dark trees.
I wish I could bend like them and be gorgeous in motion.
Who wants to sit here forever and talk about nothing?
Word after word.
I just get more restless.

III. The Second Instruction: On Sound That Begins You

After a while Prajna grows quick with new talk:

"Since you began, dear Suzanne,
my breaths in their rhythmical patterns have formed you.
The sounds of your flesh are my life-sounds.
My speech makes your minds sing.
Your thoughts are my breaths' dance.
At each moment, their step is a new one.

"In the original night and each night I breathe
the course of tomorrow within you.
Your way makes a sound in your ear and your heart;
in your dream, it shows me to you.
Trust me in you.

"Again and again you go over the same place.
You fear you are lost. You ask me to help you.
You cannot hear me.
My sound must be heard by a still mind.

"Be still and know:
If one thing abides, then all follows after.
Always my breath is.
From the beginning, something kindly is with you.
When you are lost, be still and hear my sound.

"My drone fills all the lives in the worlds
with their own being.
My waves pass through all space.
They pass through hard matter and flesh
as if bodies were light forms.

"Altogether within each thing and all things

my wisdom, *SVAHA*."
Out of Prajna a wonderful sound
fills the spaces around me.
Who can describe it?
I want to spread out to the ends of its wonder.
In the yakshis' bodies the sound becomes deep
with the darkness of earth-beings,
treble and shrill in their hair as the wind blows.
Delight makes me tremble.
Like a root pulled loose from down in me
my spirit lets go with a jerk from its set place.

IV. The Third Instruction: The Pure Place

When I return from my joy, Prajna sits in her stone self.
If it weren't for the hairs on her arms
I would think her indeed stone.
Barely moving her lips, not intoning,
she begins the third instruction:

"The time comes when few men are left
who can hear me.
As the future goes on, no one knows what to do there.
People panic at first, then agree on some plan.
Maybe one man sits down and won't act
until things come clear.
He goes past the ten million worlds
to where learning goes on.
There, past the bounds of time changing,
those who have known me
know me forever.
Go there and know me.

"Where there is one thing, more always follow.
Where there is nothing,
nothing follows.
Therefore to know truth
you must pass into nothing.

"You hold worlds in your mind,
and they produce more worlds;
clean them away, and your mind is a pure place.
Disconnect your connection to Being.
Where you are conscious, be glass unreflecting,
clear, sharp as a diamond,
without cuts that can mark you.
Where you were, there is nothing.
Completely departed, you too are void.

"It cannot be spoken of, not told by a word,
what the void is, for what word is a pure one.
Unhear what I said, and I will unsay it.
Take this world I have added
away from the worlds of the word-things.
Even unsaid, it becomes an unsaid thing.
Therefore disconnect your connection to words.
Let silence continue. *SVAHA*."

Prajna returns into stone and is silent.
The winds stop. My mind is a hollow.
The yakshis close over me like a dark umbrella.
The raft is quiet. The waves all pass from me.
I think about light beyond worlds beyond worlds
but it's still very dark here.
I am afraid here.
I don't want to be nothing.

The yakshis begin to row the still waters.
The moonlight within them shines on their moist limbs.
The ripples they make reflect on their moonlight,
the sweat and the waves ripple over each other.
The winds make a *HUM* through the body of Prajna.
Animate now, she begins to address me.

V. The Fourth Instruction: Nothing Is Ever Non-Existent

"Do not fear to be nothing, Suzanne.
That cannot be, since you are now.
Always where a thing is, something was and will follow.
You add on to yourself; there is no ending.
You flow in the fullness of all things.
Born ever, living ever, ever dying,
no one is ever gone.

"You can think of not being, but you cannot achieve it.
Matter and Spirit, Nature and Person,
always together, these never stop being.
Your matter converts between body and power
but is not discontinued.
Your spirit flows on in one stream
from deep sleep to dream,
from clear waking to trance,
flowing forever.
At the bottom of sleep, your oldest self
remembers the fullness of being
and the source of beginnings.
There is deep thought without image or story,
there time and space emerge from sounds and feelings.

"When your self is in there, being lies like a wall
all around you. That is your whole world.
But when you awake, that place like a walled box
lies beneath you. The sights of the large world
draw you farther and farther away from your deep mind.

"Now it seems there is nothing that is not outside you.
You march like a hero to danger,
you fight to control things.
You study the world, how things come and go,

how you can destroy them.
No matter how much you destroy,
you are still there, outside you.
You try and you try
but you cannot control you,
you cannot destroy you.

"Only in trance and deep sleep,
between lives and in love sleep,
is all Being and your self known as in you.
This knowing pours through and restores you.
When no thought comes,
it drips out of darkness.
On awaking, you seek a wisdom you think is beyond you.

"Alone, you move back and forth
among hope, fear, and confusion.
Being in the world, you suppose, is the cause
of your pains and your conflicts,
of enjoyment that hurts and deceives
when it does not stay with you.
Therefore what you seek is more perfect aloneness,
as if you could leap from the world
to your own place beyond it.

"You cannot be alone.
I am the full. There is nowhere I am not.
Below dreams, beyond worlds—both are the same place.
You cannot not flow in the great stream."

Prajna now chants *OM OM*, and goes into deep trance.
The yakshis let go the raft with the winds.
They stand still.

I am wakeful, with a restless eye.

VI. The Fifth Instruction: You Are Not Pure

When she comes out of her trance,
Prajna discourses a fifth time.
Her yakshis remain in their deep place.
The raft moves at random.
I grow more impatient and tense
the more Prajna instructs me.
The old words still repeat in my head,
and now there are more words.

"Look at yourself, from bottom to top, Ironbiter,
from top to bottom, stretched over with skin,
having thirty-two portions:
'hair, teeth, nails, skin, pubes, sinews, muscles, bones,
stomach, liver, spleen, marrow, kidneys, heart, membrane,
lungs, bowels, mesentery, shit, pus, bile, brain, blood, fat,
grease, tears, sweat, pepsin, spittle, snot, synovia, piss.'
These words are the text to recite,
even ten thousand times, as you picture what you are,
placing each item of you
by colour, by shape, by place, by repulsion
until all these parts stand out clear
and you stop seeing yourself as a person.

"Now eat.
In the mouth, teeth crush the food,
and a tongue smears it with spit.
Then it looks like vomit. It goes to the stomach,
a cesspool, pitch-dark,
stinking, foaming and bubbling.
Then the food is absorbed in the parts of the body,
and you know what they are.
This you must do to maintain them.

"Now consider each of these parts in a state of disease.
Think of dying. Picture intently
the foulness of corpses in ten steps:
'swollen, blue, festering, fissured,
mangled, scattered, hacked, smeared,
maggoty, bare bones.'

"Into this body, destined for dying,
you have collected
'more than three hundred bones joined
by one hundred eighty-two joints
held by nine hundred tendons,
hid by nine hundred pieces of flesh,
covered with three-layered skin,
oozing from nine holes,
from ninety-nine thousand pores.'
You have rubbed it with sweet oils,
covered it fondly with clothes and a name, 'mine.'
In all this pile, only the parts are.

"Hear, Ironbiter, the image of flame to explain you:
Your mind is a candle flame. Your body is wax.
Take away this body, this fuel,
and the flame goes, the mind goes,
you go.

"This is the reason, my Ironbiter, wise men learn
to eat small and breathe slowly.
They burn their flames low
and move rarely.
They begin to see, like a film, all their past lives.
Through hundreds of births, they can see
how flame passes from body to body,
life after life, not once going out, kept alive
on the inter-linked fuel of the bodies' corruptions.

"If you would be wise,
sit still.
Do not move.
Quiet your breath.
Consume little."

Prajna begins to breathe in a rhythm near no-breath.
Her skin is a soft light, without any flicker.
Around her, the yakshis follow her breath-rhythm.
The raft moves forward and back in the slow respiration.
The winds are quiet,
only the breaths sound.
The breath-airs massage me.
They work on the knots in my chest
that tie up my heart and my lungs.

VII. The Sixth Instruction: You Are Alive

After a while I can hear Prajna's breath grow more active.
Her yakshis return to their oars. She starts a new discourse.

"All that you need to know, Suzanne,
you can learn from your body.
Since you are alive and not dead, life is your lesson.
Consider this picture: Life floods you
as rains cover earth in the spring-time.
The wash of that being is a great one.
Its clouds are heavy and dark. Their fullness
groans in thunder. Who can control this?

"Waves reach from your mind to your toes
and they move you.
They follow your shape and spread past it.
Three hundred sixty-five nodes whirl on your body.
The wind of your breath rubbing their rims
makes the tones of glass organs.
Through their spiralling funnels,
the waves, back and forth,
pass the skin's wall.
The pitch of the nodes raises and lowers as the waves flow.
These are the surface sounds of yourself you can hear
when you sit still.

"Now I will take the pads of my fingers and rub you.
I stretch out small circles of skin
and they carry drummed pats to the hollows of organs,
to the wood boles of long bones.
From the lobes of your ears to the hams of your thumbs,
from the bridge of your nose to your foot pads,
I rub and I pat all your nodes
in consort with the pitches and speeds of the waves' flow.

"Now from your centre
the bass of my drone sounds.
Now you are all tuned."

I am full of vibration.
My matter has turned to air only.
I feel life full, its silver-blue aura around me.
The sound of my being, to me, equals all being's sound.

Then I start to come down.
My body shrinks back into knots and the tones stick.
"Prajna, where have the sounds gone?"

Now all I hear is my own voice:
"The music was too short!"

Prajna, I think, being old, has forgotten impatience.
Nothing matters to her.
She goes back to her stone form:

"There is, Ironbiter, no life-flood, no consort, no great drone,
no wave power, no full being. Separation of parts
is life's one law. Sound breaks up like all things.
Relinquish these myths, these nice pictures you like to imagine.
They make one thing clear and ten things muddy.
Beyond life and the body, my freedom, *SVAHA*."

VIII. The Seventh Instruction: Nothing Is Good

I sit back on the raft, but I'm angry.
There is steam from my ears and my sleeves.
It is nothing to Prajna.
Her eyes are stone eyes.
The root of her tongue is a stone.
Yet from its hardness she brings forth instruction.

"Anger is useless.
Only by violence
can you express what you feel now.
That will lead to rebirths of the same kind.
Again and again, your lives will keep being the same lives.

"Give up this anger that's in you.
Make use of your body, your cloth, and small food
belonging to no one.
Be austere with yourself.
Watch your mind.
Consider the chain of pain that all life is.
But your thought about pain is a mind-thing.
Give up thought. Be quiet until you know what is better.
The heat of your yoga will rise in you.
Beads of sweat will pour out.
Then you will feel cool. You will feel nothing.
You will be as a stone.
And I can tell you some more about wisdom.
Anger is one way, instruction another.

"Repeat to yourself, Ironbiter:
'I am not anywhere, nothing is mine.'
That is the wisdom of how you are empty in two ways.
Now learn to recite the great list
of the forty-two ways all the parts of all bodies are empty.

Each part is:
'impermanent, suffering, prone to disease,
impaled like a boil on the needle of suffering,
a barb injuring itself, miserable, afflicting,
alien, crumbling, calamitous, troublesome,
terrible, disadvantageous, brittle, unstable,
shaky, no shelter, no refuge, no protection,
no safety, hollow, vain, empty, not-self,
tribulation, prone to reversal, not substantial,
murderous, undoing, outflowing, conditioned,
death's bait, prone to birth, to decay, to illness,
to sorrow, to dying, lamentation, pain, sadness,
despair, prone to defilements.'
This is the great wisdom, to know
how nothing in life is a good thing,
how all things are parts only, full of suffering,
otherwise empty.

"Since you are empty, sit still and be empty.
If nothing is good, all moves are false moves."

This Prajna has only one thing on her mind:
she wants me to sit still.

IX. The Eighth Instruction: Pleasure Is Good For You

In hardly a moment Prajna's stone tongue becomes fleshly.
Her cheeks and her body plump out.
Was ever a person more two ones than Prajna?

"You are trapped in your mind, Suzanne," she tells me.
"Get back to your senses."

The yakshis begin to exude a dark fog of rich scents.
Sandal paste on their breasts,
white jasmine in the cups of their navels and ears,
rose-wreaths on girdles and necks,
bracelets and anklets of lime-blossom plaited
blend with the sweet earth smell of their dark sweat.

The ferry-girls sway and they stamp as they row
in the rhythm of the slow dance;
the flesh-beat of foot pads,
of arm pits on large upright round breasts,
the loose winds of heavy head hair and garlanded full hips,
all change my ear-drums and ear-hairs to be not of my head.

My lips and my tongue sting with the salt of their heat.
On their buttocks and thighs
the round of my hand is not shaped as my palm
but conforms to their curves and becomes them.

Prajna herself is a live jewel
wrapped in the velvety shade of the yakshis.
She sparkles in my eyes.
The hard weight of my head falls away
from the vision her light is.
Now I am in blissful trance.
The wash of the waves is the same as my heart wash.

The winds are my own breath.
Where I am is bright air.

Prajna recites the great verse of the old days:
"*OM. Purnam, purnam.*
Pleasure gates lead from your body.
Their holes are the only connection
of inside and outside.
Between you and the world let there be a rich flowing.
Where the gates have been shut and no pleasures come in,
you are in prison. Nothing inside lets you out.
Open out. Let my fullness pass through you.
My fullness floods out the bounds
between you and beyond you.
OM. Purnam, purnam."

My bliss is a nice thing.
But wherever whatever I was had gone,
my old self comes back slowly.
It is restless for home.
It wants its own place in my head
where it can close out these pleasures
and consider what pain and what death mean,
and why bliss is not perfect.

When I return from that place, I am alone.
Where Prajna was, there is only the seat pad,
in the place of her yakshis, their foot traces.
The raft moves at high speed. Where am I going?
I long for a place where nothing will happen.
Quickly I shut up my senses and go in.
I go in as far as I can, trying to leave that speed out.
When I reach a still spot, I breathe and I breathe there.
My breath slows. I rest now.
I sit on a stone in the pit of my stomach.

X. The Ninth Instruction: Perfection

"My Prajna," I say, "is this the farthest I go
from the raft and the waves and the rhythm of the yakshis?
I want to be sealed in alone,
apart from the change that goes on there.
Only a silver-blue breath
ties me by a thread to the world of the living.

"In this place, left alone by myself, I can,
in the work of one life-time, accomplish perfection.
What I have stored from the past in my mind,
as I take the steps, by myself, of my own thought,
leaves me and goes out to the wilderness around me."
So I tell Prajna.

"My Ironbiter," she says to me,
"let me tell you the lives you must live to be perfect.

"You are living the life of an infant whose naps
fill the whole day.
When is your mind clear?
All you can feel is the urge of your growing.

"Again, you are a child who's afraid of being wrong.
You think you'll be loved very much
if you are the best one.

"You seek your own way,
digging your ruts into you as you go in circles.

"Perfection of wisdom grows up as you grow.
After a lifetime of lives, you will be old as I am.
When all that you once knew has died,
your privacy equals

the loneliness in you.
When you disappear, at the end,
where you are empty, my perfection becomes you.

"You know how to breathe by yourself—that is the first step.
But to be gone—that is what evades you.

"'Gone, gone, gone beyond,' my Ironbiter,
gate gate paragate is the word of my wisdom.
Neither in worlds nor in you,
'gone all beyond, awakened, *SVAHA.*'
'Gone' is my word.
When the worlds or your loneness weigh on you
repeat it, and your mind will be mine.
It is the love song that weds us. 'Gone, gone, gone...'
will carry your longing to go
out of your mind."

XI. The Tenth Instruction: A Stream out of Oceans

I grow backwards toward sleep and away from perfection.
I dream a great statue, stone Prajna,
calm at the vanishing point, disappears
as I run
to regain a beginning.
The powers of her end pull against me.
Even to stay where I am, I must lean deep.

I float on the raft and the yakshis move round me.
I lay down my head on the warm lap of Wisdom.
She strokes into my forehead the dream
of the world as her dream, saying:

"I weave what you see and I draw it back in me.
As the tides come and go, as the moon swells and wanes,
I flood and I dry up the shore,
I lighten the night and I leave it in darkness.
Passing from dream to deep sleep
back to dream and to waking,
I pour the life-stream from the oceans within me.

"Be still. I will pour myself steady and smooth.
The waters gathering within you
grow fuller and fuller with my being.
Your dreams are my dreams. Your waking is my eye.

"This sea is my womb. My dreams there are real dreams.
I bring forth the lives of my children, the worlds' beings.
Would I dream and not choose empty sleep
if I did not love dream?

"OM is my sea, and the fullness of all things.
I pour forth, I draw back in the turns of my dream.

Life fills and then drains you; still, in me you are.
I awake, yet behind my awaking I dream.
There is no end to the streams from my oceans...."

Prajna goes on and goes on
telling the tides of her empty and full being.
I nod and I nod with the drone of instruction.
In a great nod I roll off the raft.
Before I awake, I have sunk past the floor of the first world.
I keep falling head first.
"My Prajna," I say, "is this a new dream?"

SHAKTI
Power Rises

I. The Seven Wise Women and My Linga-man

In me:
Too much is in me.
It gathers and roars.
It weighs down my head and empties my body.
My up side stays down.
If I am a world, my feet are Cold Mountain.
These are primeval snows on my soles.
This is their melting cold, I am a glacier.
I flood and I silt my own head in a valley.
Past me a sea's roaring out-roars
the roaring within me.

In me:
Seven wise women inhabit the banks
of that cold water stream from my Cold Mountain.
In each place as they sit
they gather my roars and turn them to *HLIM* and *OM*.
They know the ways of the stream,
the changes from dark-running waves through foam
to floors paved with moonstones,
how the sounds of the currents knot and unwind
past the narrows.
Year beyond year they have learned
to live by the will of the waters,
to pass and not stay,
to be washed in sea
and rise up in vapour.

On the ridge of my foot pads,
standing or sitting, year beyond year,
my linga-man, my penis-head, Svayambhu,
admires the space where he is not,
the place he cannot be where thought is absent.

He says, "The truth is silence."
(He talks to himself. Who else wants to hear him?)

My body, upside down, lies stretched
beneath and behind him;
on my calloused foot pads, on my highest point,
he barely knows me.
My sound does not move in his ears.
When he talks, it is beyond me.
In a garment of ashes, his colour is space's.
Only his shape, the shape of a man,
makes its mark on the sky there.

Svayambhu has left my ways beneath and behind him.
His shape marks the void beyond, he would be its master.
His form charts where distance is; it makes far more far.
To the corners and ends, it surveys there.
The top of his head grows long on the wall where the stars bend.
Still my feet hold his foot pads;
he is a shadow of me in the sky as he stands there,
or I am his shadow.

After ten thousand years,
a light begins somewhere inside him.
It fills him up and through,
making a glow in his ash skin,
drawing his lengthening space
to some centre.

"Who is this bright one?" he says.
Whatever it is, it is sleeping.
He moves with his feet on my feet.
"Who is this?" he says.
"Wise women below, do you know who this is?"

The seven wise women live on their seven tiers

on the banks of the cold water stream
as it falls from my Cold Mountain.
Jambu, highest and oldest,
sits in the shade of a rose-apple tree
where ice begins to melt
from the edge of Cold Glacier.
She is the first to answer Svayambhu:
"I will tell you the way you must go
to find out what that is.
Take this fruit from my rose-apple tree.
Let its red nectar run down the stream
to my sister beneath me, Plaksha,
a full moon like a fig, heavy with seeds,
pale green shadowed purple.
She will let flow the pulp of her moonness,
a foamy draught, down the stream to our sister."

Svayambhu takes up the fruit and squeezes out nectar.
It runs in the clear iced stream
to the wise woman Plaksha, younger than Jambu.
She sits in the fig-tree's shade a step down the mountain.
Plaksha says to Svayambhu,
"When you have tasted my figs,
scatter their pulp in the stream
as it goes to Shalmali."

On the third tier, silk-cotton grows
in a tangle of thorns. There the sister
Shalmali sits with her weaving.
She is the mother of action, and this is her wisdom.
She sees the dark patches and moon pulp,
the signs of her sisters,
twist in the cold running stream.
She says to Svayambhu,
"Prick your finger with a thorn.
Take your blood on silk-cotton.

Pass on this fruit of my tree in the stream
to Kusha my sister, the mother of growing."

Where each grass is a tongue
but no wind moves it to sound
Kusha takes her wisdom from silence.
She lays a grass blade to her body—
wrist, throat, heart, temple—
wherever thin pulse skin can hear the vegetable quiet.
Like an unmoving flame, an unbroken water,
the sound of grass finds its voice in her silence.
"Go down," she says, "in the stream with the grass
to my bird-sister, Krauncha."

So Svayambhu passes on,
past the marshes and shallows,
past the sand bars, tide pools, and mud flats.
There Krauncha, wise mother of voices,
blows through the long throats of the snow-feathered cranes,
bronze ibis and white-purple heron,
through the cinnamon necks of the curlews,
the dunlins' *chu purre*,
the plovers' long whistling and moaning.
All the birds embody the body of Krauncha;
they carry it in them, around them.
Svayambhu floats in her song toward the flood plains.

Shaka, mother of peace, the sixth of the sisters,
sits on the plains in her gardens.
"Svayambhu," she says, "pick of my vegetables,
courgette and aubergine, sweet grains and herbs,
which, grown large on the moonlight,
give their patience to the minds of those who eat them.
Then in your sleep you will know.
This is the way
to Pushkara, our sister, wiser than we are,

past the earthen tiers,
her nest a thousand waves in the great sea-hollow."

Svayambhu's mind grows calm.
He lies in deep sleep on the green lap of Shaka,
on the shore by the gardens.
The tides, Pushkara's fingers, rise up and reach him.
Pushkara carries him deep into ocean.
In her hands his sleep fears no drowning.

"Svayambhu," Pushkara says,
"you ask about the glow in your body.
That is our mother, Kundali, goddess within you,
power you have not known,
asleep at the root of you.

"You have left your solitude upon the mountain.
You have followed the stream that leads down
to the women within you.
Now look in the mirror of Kundali.
One who is more inside yourself
than you have ever been
appears there.
In her brightness you will see
yourself as another.
Enter Kundali.
Pour into her
your isolation. *SVAHA!*"

II. Kundali Awakes

Svayambhu thinks, "Why have I come here?
I belong on the mountain.
How can I have forgotten?
Have I climbed up and up, only to go back down?"

Kundali's body moves and coils deep in him.
She is more supple and more strong by far than he is.
In wide arcs, side to side,
from the seat of his being, she stretches upward.
She rubs the low centres of his spine and makes them open.
She fills the heart space where he thought his soul was.
She carries his two breaths, life and death,
to the right and left, on paths beside her.

Kundali rises into the root ways of his brain stem.
His neural fluids are the streams she bathes in.
They pass the lustre of her long flanks through him.
But she stops just short of where his thoughts are.

Kundali circles Svayambhu's brain.
His mind sweats and trembles.
Enter me here, he thinks.
Fill up my mind too.
He longs for his thoughts to be her movement only,
to disappear where she is secret.

She feels his longing.
But if she penetrates too far, it will destroy him.
She holds him carefully where he can hear her heartbeats.
Her time is slow, and her heart waves long;
his beat is quick beside them.
Her rhythms speak to him:
"How I long for you, Svayambhu!

How I desire to pierce the whole of you,
to reach the place of love.

"Hear me, Svayambhu.
On the top of you is the smallest place there is,
like the ten-billionth part of a hair it is small.
This is the one empty place,
one place that can never produce another.
It is void and hollow, an *O*,
a desert place, air, soul, and spirit absent.
There is no birth, no perishing.
No other enters, no other comes away.
It is the seat of your person, O Svayambhu,
it is your self, Svayambhu, self-begotten.
In that small place I will come up to you.
There I can take you and I will not harm you.
There we will unite.
Your nothingness will be my husband."

Kundali rises up,
through his centres and spirit paths,
gathering his *rasa*, his life force.

As she comes, his body falls back.
He is breathless. His mind stops.
She carries him up where his paths end.

Her lips clasp the small hollow.
As they rub there,
they draw out the *laksha amrita*, red splendour,
the good drink that cleans the death from living.

When Kundali is full, she lets go
and the good drink flows in her.
She retraces her steps through the paths of Svayambhu.
As she descends, she returns to him gently
his *rasa*, his life force.

"Svayambhu," she says, "wake up, we are one now.
Feel the bliss of our union within you, around you.
We are the same one,
the androgyne, husband and wife, *Ardhanari*.
I am your power, your life,
and you are my person, my knowing.
Be conscious!"

Kundali speaks out, but Svayambhu does not hear her.
He starts to grow pallid and dim, fragile and corpse-like.
The life force has sunk from his skin,
his organs are soft ash.
He hears her voice far away through a lengthening tube.
Then the darkness flows out through his ears
and who knows where he is.

"Svayambhu," she says, "it is time to wake up now."

He is too far gone.

Kundali crawls from the body of Svayambhu.
She breathes through his cold gray lips,
she burns in his loins,
but she can't start his brain going.
She tears at her cheeks, her breasts, and her hair
with her long nails.
Then she takes up his body and hangs it around her.
A great moan comes from her.
She walks to the burning grounds
with his limbs flapping on her.

She must carry out *homa*, rites for the death of a lover.

III. Kundali Makes Love to the Corpse of Svayambhu

In the cremation grounds,
at new moon, on Tuesday at midnight,
Kundali, naked, with dishevelled hair, begins her *homa*.
Around her the spirits of householders come in hunger.
What has she brought them? they ask.
They want cakes from loved ones.
They do not want Svayambhu among them.
He was a linga-man, childless,
not given to households.
His death space is not theirs.
Go to the grounds where the devils are hungry, they say.
They may befriend him.

Kundali takes up Svayambhu and goes on.
She cannot see through the smoke of the burning.
Out of red light in the dark night the devils come running.
They are hungry for blood; they drink it for power.
They do not like Svayambhu.
Take him away, they say.
He was childless, he gave up blood,
shed all his powers to be clear.
Take him on to the grounds where the saints live.
They may accept him.

On through the burning and smoke
Kundali goes till she reaches a crest in the graveyard.
There saints' spirits sit and pray for the living.
That one is not for us, they say, seeing Svayambhu.
He was a cold man, one alone;
he thought every man should take care of himself
and not meddle with others.
Take him on to our brothers, the mad ones,
in the hollow beyond us.

Kundali passes down from the saints' hill.
As far as she can see, there is smoke and burning.
The path goes downwards,
but she can see no hint of what is down there.
At last she comes to the ground of the mad ones.
They talk and talk, all at the same time.
Svayambhu's silence they don't like.
He was one alone, a blank mind, they say;
he lived past words and things, in void space.
Take him to our brothers who wait by the river.
See if he belongs among them.

The river stretches out beyond the mad ones.
The smoke is more yellow here, and the spirits are dense.
Their time is come to leave the world of death.
To each in turn the voice of a mother
calls out from the water, and they go to her.
No, they say, this is not the right place for Svayambhu.
He was a blank mind, clean of the womb,
not born of a mother.
It is not for him to wander in the womb space.
Go to the blessed ones in the halls beyond us.

At last Kundali comes to a great house.
There the most blessed ones sleep in their rooms
past the smell of cremation.
It is peaceful and calm; all the sleeping is dreamless.
Kundali looks for a room for Svayambhu,
but each room is full without him.
The Father of all ones comes out from his chambers.
He says, "Beyond my halls,
past the lights and the darkness, the hungers and sleeping,
on the couch of your heart
is the place for Svayambhu."

Kundali closes her eyes and goes into her body.
She sees her lover lying at the top of her head in a trance death.
Gently she carries him down to her heart.
She surrounds him with breathing.
Though he is cold, she warms him with her heat.
Though he is far away, she gives him nearness.
Though he is bloodless, her heart beats through him.
With her magic *HUM* she caresses his organs.
Her hand stamps the *HUM* on them.
She seals his corpse onto her living body.
Together they form Ardhanari, Manwoman.
They are two. They are one.

IV. Svayambhu Dances

While Kundali is rapt in her heart doing *homa*,
the power of her sticking brings back Svayambhu.
He wakes up in the sweat
of a good dream turned to a bad dream.
He sees the burial grounds and the corpses burning,
how Kundali sits on a carpet of bones,
how she is ragged and wasted,
how she has given up her life
to join him in his death.

"Kundali," he says, "what has gone wrong here?
I am the corpse.
You are supposed to consume me.

"Stop doing this *homa*.
Do blood death on me.
Tear off my limbs, tear out my organs.
Be a vulture. Clean the flesh from my bones.
Put your power where I am. *KRIM SVAHA.*"

Svayambhu cannot break Kundali's *homa*.
He mats up his hair. He spreads his skin with more ashes.
He paints himself with red blood and black bone char.

"Kundali," he shouts, "I'm the one who is dead !
You're supposed to consume me! Get up!
Do burnt death on me.
Make me charred bones.
Make me mud and ashes. Do it! *HRIM SVAHA.*"

Still, Kundali is rapt in her *homa*.
Svayambhu places his left foot first,
HRIM SHRIM KRIM SVAHA,

he chants seed words
to the drum of his foot beats,
in a frantic dance he pounds the grave ground,
OM SHRIM, the sound of his whirling arms,
HUM PHAT, his linga beating his thighs,
'HAM SAH, SO 'HAM, he becomes power,
he is *vajra*, hard lightning,
his necklace of cobras
writhing and flailing, his blood and ash body
glistening, glowing.
The powers from his fingers and toes, from his linga,
form bolts in the black smoke.

Still, Kundali keeps her perfect *homa*.
Svayambhu cuts into his body; ashes pour from him.
His hands and his eyes glow red,
his linga is an ingot of molten iron.
He leaps and the air cracks.
His roars become detonations. He is much too violent.
Then his linga breaks off from his body.
It falls through the earth to the other side.
It grows and it grows.
Who knows the end of it.
Svayambhu collapses. He is now only ashes.
"My hot ash is my seed for you, Kundali..."
these are his words as his lips also crumble.

Svayambhu's hot ashes fly into Kundali.
In her womb's sleep she conceives
a feverish burning.
Heat breaks her *homa*.
She must rise up and follow the steps of her lover.

There between spirits and shadows, corpses and bones,
like a hideous ghoul, swinging withered breasts,
flaying with the lash of her tongue,

skin pitch-black from the death fires,
black snake hair writhing and coiling,
blood and gore caught in her fangs and nails,
Kundali takes up the dance of Svayambhu.

The power of her first step
stamps out the pockets of air that cushion the ground.
Down to the space in the atoms of things,
there is compression.
Bodies collapse on themselves.
Life begins to lose its conditions.

The people call out in their prayers to Kundali:
"How can we calm you?"

"Bring me the burning linga of Svayambhu.
I will take the form of vulva, of yoni.
Svayambhu will rest in my form and we will be quiet.
I will take him back to Cold Mountain
and we will make love there."

The people meditate on the sign Shri Yantra.
They put Svayambhu on Kundali.
They draw the diagram within their own hearts.
They bind linga and yoni into *Ardhanari*.
KRIM HUM HRIM SVAHA.

V. Our Cold Mountain Household

Kundali takes her lover to her mountain cave,
to her chambers where her lion guards her.
For a thousand years they lie in love there.
Hour after hour, Svayambhu invents more love plays.
Each year they enjoy each other more than ever.
But Svayambhu will not hear of children.
He always spills his seed in other places.
"Let's stick to pleasure," he says; "offspring is trouble."
He goes away from her in sleep and in yoga.

Kundali says, "It is right for me to have a child now.
It would be wrong to make me barren."
But Svayambhu cannot think of children.
He says, "Content yourself with mind borns."
But Kundali's mind is made of matter.
She wants to think a son just like Svayambhu.
She thinks and she thinks,
but she needs Svayambhu's person to beget him.

Kundali moans,
"All the universe bears children but Kundali."
Again and again, she wishes for her own son.
How she wants a little one to kiss and fondle!
Svayambhu says, "I do not want a son around me.
It is not for me to fuss about a household.
They say a wife is a rope for a man;
children choke and hang him.
I am a linga-man, yogi transcendent.
My pleasure is apart from birth and dying.
Therefore let us enjoy our loving without offspring,
taking delight in one another only."

"All this is true," Kundali replies.

"Still I do wish for my own child.
I will do the rest if you beget him.
Yours is indeed a yogi's life, and not a father's."
Svayambhu does not like to hear this.
He goes to sleep and leaves Kundali brooding.

When Svayambhu wakes up, he mocks Kundali's sadness.
He pulls off red cloth from her dress and makes a doll son.
Kundali says, "Just stop your teasing."
But she takes the small son-shape in her arms.
At the touch of her breast, the cloth child quickens.
With magic hands, Kundali rubs its body.
"Breathe now," she says, "*GAM GAM*."
The child fills with breath as one alive.
Milk flows from Kundali's breasts.
The baby drinks and smiles at his new mother.
Then Kundali gives her sweet son to Svayambhu.
"Feel," she says, "the happiness of having children."

Svayambhu takes his son and checks him closely.
He says, "I see on his neck the sign of the look of Saturn,
an injury mark from the planet of self death.
Therefore before it begins, his life will soon be over."
The baby's head is so large, it breaks off from his body.

Kundali takes from Svayambhu's arms the headless body.
She is dumb with sorrow.
"Do not cry," Svayambhu says.
"There is nothing so ugly as tears and grief.
Stop. I will revive your son."
But the neck is too small.
The head will not join again to the shoulders.

Kundali goes away in mourning.
When Svayambhu speaks, she looks right through him.
She cannot forget the broken baby.

Svayambhu thinks, "This son from her outer cloths
is part of Kundali.
I must find a new head to join to his body."

Svayambhu looks for a head in the north lands.
Soon he finds a small elephant, healthy and handsome.
He takes off its head and brings it to Kundali.
She fastens it firmly to her baby's body.
She lets her tears rinse it and wash it.
The baby awakes as if it had been sleeping.
He is a very cute one, short and fat,
with a nice pot belly and a plump-cheeked chuckle.

Now Kundali has a son to kiss and fondle.
She feels lucky when she rubs his tummy.
But in Svayambhu's mind, he is a rival.
While the parents are as one, the child is another.

VI. Our Household Increases

Kundali sees Svayambhu's mind is troubled.
He lies at loose ends in her cave,
smokes ganja, and grumbles.
His trouble crawls into the hairs
in the knot on the top of his head
and colours them smoke gray.

Kundali smooths out his forehead to soothe him.
She feels his brow grow hot from the rubbing.
Beneath her hand, a sweat bead rises.
A drop of red *rasa* pours out
from the node of his brow into her palm cups.
There in her hands his sweat forms an infant.

Svayambhu says, "Look.
You have made for yourself another monster."
But the child is too ugly. Kundali rejects him.
Because he has hair for eyes, she names him Eyeless.

Eyeless wants Kundali to adore him.
He goes and stands on one leg, his arms raised above him.
He gives up a piece of his flesh every day
trying to please her.
When he gets to his bones, Svayambhu says,
"You have got my attention.
What do you want?"
Eyeless replies, "I want Mother to love me."
Svayambhu says, "I will give back your flesh.
I will give you big sex and big power.
You will rule everything.
But still you will not see your mother
and she will not hold you,
unless you can win her from me."

Eyeless begins to rule everything.
Svayambhu goes back to his place on Cold Mountain.
He goes into trance and he cleans from his body
the signs of his earth life.
He regathers the vigour
he lost in long loving and offspring.

Kundali beautifies herself in her mountain chambers.
While Svayambu is gone, Eyeless tries to seduce her.
He is mad with the pride of his powers
and pretends he's his father.
But Kundali sees through him.
She takes off her beauty and puts on her outrage.
She skewers him up on a pike and leaves him to dry there.
He dries and he dries, for a year and a thousand.
He says, "I was born all wrong and no one can right me.
At least take my wrongness away.
If I am not for you,
let me worship my father."

Svayambhu returns. His retreat has refreshed him.
He accepts the worship of his monster. He says,
"I give you your wish. You can love me forever,
and no more wrongness."

Now Svayambhu and Kundali go to her chamber.
Year after year they invent ways of loving.
Sometimes they wear costumes.
If Svayambhu dresses as moon in the shape of a mountain,
from his feet to his head he is snow white, shining,
then Kundali's black body coils round him.
She becomes Ganga, dark river,
wrapping his glistening moon-skin.

One day in Shravana, a hot month,
Kundali finds out where Svayambhu is spilling his seed

and she drinks it.
She goes off and hides
in a thicket of reeds on East Mountain.
The six sage mothers of the earth have come to bathe there.
They will bathe in the light of the new moon
when it eclipses the rising sun for one moment
(that time is propitious).

At the time of eclipse,
Kundali lets the spilled seed out among them.
The mothers form a nest of six sides closed in red cloud.
On the fourth day, a child with six faces is born,
a wonderful boy, Kumara, bright as the sunshine.
He is the patron of boys who wear girls' clothes
and girls who wear boys' clothes.
If anyone stands on a border of two things or more things,
one of the faces of Svayambhu's child
smiles for him.
This is the happiness power of Kumara the sun boy.

VII. Kundali Explains Things to Svayambhu

After the sun boy is born, Kundali grows dim.
She has lived a long life, and she is tired now.
She retires in herself and no longer rises.
Her shape as she sleeps is the shape of a tight curl.

Because Svayambhu has done the age-magic yoga
he is not old.

He is glad to be free now.
He returns to his bachelor life
in his place on the Cold Mountain.
The clouds of the *ganja* he smokes
make the air high there.

After two thousand years,
something begins to grow restless within him.
He remembers Kundali,
how in those days long ago she overpowered him.
He says,
"Here I sit on the ridge of the world's highest mountain,
untroubled by life, as empty as space,
and she won't let my mind be.
For two thousand years I was happy.
Now she wants to confuse me."

Kundali takes the form,
from the dusts in Svayambhu's pores,
of a spirit of odour.
Her scent rings around him,
but he's unsure where she is. She says:

"Have you been sitting here all these years,
and still you do not understand, my darling?

You can still be yourself. Recognize my illusion.
Do not be confused that we seem to be different
each from the other.

"You are the nose, I am the smell,
you are the part, I am the completion,
you ask the question, I am the answer:

"We are really just one being.
Set your meditation on oneness.
Forget your solitude.
Around the centre of our union,
everything multiplies until full to bursting.
We form a mesh, and what is not in it?
We are the cross weave, Time and Illusion, Kala and Maya.
You, Kala Svayambhu, count the passing of time,
the warp of the mesh, the grid
that crosses through life from the first to the last things.
I, Maya Kundali, measure and show
on the weave of the weft
the story of living and dreaming.

"My darling, because we are meshed in each other,
when you think that you think by yourself,
it is illusion.
Do not be upset that I trick you.
Be glad that I tell you the whole truth.

"On Tuesday at midnight
meditate ten thousand times
with the mantra *AHO*
on the flower sprinkled yoni of your Shakti,
Maya Kundali."

VIII. What To Do With Svayambhu

Svayambhu complains:
"You may be happy. It's your oneness.
You like being one because that leaves me nothing.
You want me to become you.
If I'm going to be dissolved, you should go with me.
Why should only you be something?"

Argue. Argue. What a will has my Svayambhu.
Kundali says, "Don't worry. I have room for that too."
She takes on the form of a star.
She becomes another to Svayambhu.
She is one he can count on, shining above him.
He aims and he aims at her centre, he pierces and pierces.
Her fullness spills over his head, but he never depletes her.
He is a mad one, her darling,
in contention for nothing.
The wilder he gets, the more she adores him.

"Listen Svayambhu," she says, "why can't you be peaceful?"
"Then I'd stop being Svayambhu."
"Well, travel out then.
I will guide you outside you.
Map six realms lying beyond you.
Go from Earth into Bhuvar, region of planets,
and out into Svar, where there are constellations.
Then go to Mahar, great space past the pole star,
and Janar, clean of mind-waves and matter,
blissful to be in, and reach far Satya,
the place where pure Truth is.
Past Satya lies the unnamed place.
Wherever you go, you will see
its messengers moving beside you.
You have their nature.

Stay there and be with them."

Svayambhu begins to go out.
His gathering speed elongates his ear-hairs.
Their tuning prongs tune to the space drone.
Heart, breath, and thought sounds,
since they are earth-bound,
soon fall behind him.
His nerves move on ten billion currents,
spinning to whorls, knotting and splitting,
smoothing, exploding.
When he passes the far house of Satya, he is a pure one.
All around him are pure ones, perfected as he is,
in the place where being treasures perfection.

IX. The End of the Manwoman

It has become very quiet.
So much has happened, I can't tell where I am, who I am.
I look in myself.
Once I saw there a man, my Svayambhu,
once I saw there our pair, *Ardhanari*,
now I see only a woman.
She chides me:
"You love him and not me.
You want his low voice, his strong chest,
his big thighs, his tall stature.
Why can't you admire me?"

As she talks
she takes on the form of a daughter, a young girl,
Kanyakumari.
She lengthens her eyes into almonds.
She fills out and lustres her lips and her long nails.
She lifts up her breasts, draws her waist very narrow
and makes her hips ample.
Around her ankles and waist she fastens small gold bells.
She circles her wrists and her arms,
her neck and her forehead
with pearls and carved rubies.
On her warm spots she rubs deer musk oil.
She plaits her hair with garlands of jasmine and mango.
Her movement is liquid and dark.
Who is this now?

She kneels down to earth with her palms on the ground,
she presses her earth-scented palms on her forehead:

"Earth, Ironmother,
you who lie covered beneath me,

you whom my thought cannot reach,
even my heart cannot find you,
since only in moving upon you I know you,
since all of your touch is below me,
allow me the press of my feet on your body."

She chants the Chali foot rhythms as her feet dance:
"*TA ITTHI NAKA DHINI.*"
First she jumps low, then stamps faster and faster
to the drums of heel, sides, ball, full foot, great toe:
"*TA ITTHI NAKA DHINI.*"
Now raging, now wondering, now lusting,
her torso, her eyes and her hands tell her story.
She speaks with the deep ground,
the woman she comes from and will be.

Introduction to the Second Cycle

*Time passes in me and around me. My children grow up.
My husband dies. I go to the other side. I come back again.
My grandsons are born. Death turns to life again. My
work becomes clearer. I begin to teach what I know, not
what I don't know. There grows fear, there grows terror.
There grow the demons against life. I keep singing to the
Mother in the dark night.*

Increasingly, as a woman beyond my personal householder
stage of life, I feel a need to link my sense of a goddess within, to
a sense of the divine acting within the outward course of human
time. A new round of *Devi* begins with Indian stories of the
Mother and Her Son incarnating proto-historically or historically
on Earth. It interweaves variations on Indian philosophies and
poetics of timeless timely vibrations, and moves toward a yoga
ideal of clarity and focus, a restraining of my waves of mind and
word, their centring in a simple prayer.

MataPita
Incarnations &
Conversations

I. A Question Begins in the Subtle Fields of the Mythic Ante-Tempus

Loving children and grandchildren, not confident of the future,
concerned among humans in the family of living beings,
not confident of our future,
concerned in the lineage of fathers, of mothers,
I seek in the form from which I am born,
wherefrom my rebirth is.

Homage to Ma in my going beyond,
Homage to Ma in my going within,
Homage to Ma in my in-between.
Homage to Pa in the deep course,
Homage to Pa in the wheel of pain,
Homage to Pa in the pause.
OM NAMO NAMAH.

In the astral zone around my body,
in my brainstem's mountain,
in my caves of head and chest and bowels, in my rivered veins,
in the river Ganga, in veins of Earth Mother, in wind and rain
drone histories of birthful incarnations,
love songs in bliss and separation,
transmissions of peculiar conversations.

The drone begins before dream pictures birth.
Attention is calm. Illusion is waiting, enchantment is waiting,
 unspoken.
Ethereal proto-sages sit in intense meditation
in the mind fields of the birthless Sage. Without words, they
 desire to ask,
with the mere raising of high brows, by inner hum intonation, as it
 were, "*Hmmm?*"
Hearing their mental quest, the Ever-Merciful Sage beats "*dam*

dam," fourteen *dams*

on his *dam*-drum. Forth from these grossless "*dams*" resound aural
hues,

a rosary of tone-tones, fifty and one linked undulations, their
quest's first festooners.

Each sage's mind speaks its first thought, "I am mind," in those
fields.

As yet there are no throats, palates, lips, teeth, tongues, no gross
earthly bodies.

The Sage says, "My sages, I have given you subtle sounds.

They vibrate in waves to make your minds fruitful.

I put you in charge of their stimulation. Your power is ambiguous.

It can seed good fruit or bad fruit. It can destroy you. Be vigilant.

Weed the bad and cultivate the good. Be not egotistical.

Among the sounds, '*aham*, I, I, I' can seed pride.

In all my mentalverse yet to issue, my enigma of self-knowing
starts here."

The sages bow their noses to their ground and get the sounds in.

As yet they know no real temptation; their desire is a vague
intimation of fullness.

Each sage's mind speaks its second thought, "This knowledge
constrains me in my field."

The Mother of Fullness, the Sage's wife, listens from Her cave.

(The Sage had dared immodesty in dance, showing His linga

to the beat of His *dam*-drum. Ma kept Her yoni veiled within Her.
He said,

"It is I Who dance the cosmos into being, and also into
destruction! I have won!

Your power is second to Mine! You are but the source of My
nuance!"

She, staying less flashy than He, did not argue.

She did not flaunt, "I am the Mother Ground of Your mind
fields!")

"The way things are is agreeable to me," She says demurely in Her

veil and cave.

"My Husband's delight in His drum and His linga is My most powerful illusion."

She bows to the Sage's linga show. She makes space for Its exuberant protuberance.

Out of Her pretence as His mind veiled in Her cave, She opens Herself.

In Her inward space, the vocables of His drum echo multiplyingly.

Out of Her womb on a lotus umbilical comes Son,

One Who is Perpetual Birthful Incarnator.

Through the lotus chord, Her womb's *OM* resonates to His body.

Down from His mind, subtle sound vibrates a heart and a navel, a mystic spine.

It shapes a person, a mystical human vertebrate,

co-idea of a vertical body-vehicle perpendicular to the mind fields of the birthless Sage.

Having been born upright, Birthful Son strides on the mentalverse:

his feet traverse the astral and Earth fields and sub-fields,

the bliss fields of caved Ma and the mind fields of Sage Pa.

He makes an Act of Sacrifice, the first act of a born body.

"I give My body," He wills. "Divide into birth souls. Be embodied beings.

Let time be measured by the birth cycles of these bodied beings.

In birth, sacrifice eternity; in death, sacrifice time.

Act for me, as I for you." What is this sacrifice? I don't know.

How does He will such a blissless mindless deed? I don't know.

Is it a blissful mindful deed? Can it not be?

Is it to unconstrain the sages' knowledge in their I-fields?

Let me see if it does that. Let me see where it goes.

Mother says to Son: "Well done, Son.

You have manifested My most mysterious illusion."

In the superior portals of Son's larynx, bodied sages shape.

"Hey you, sage speakers from my throat circle!" He instructs them:

"Let your hymns and soberer utterances mix the veiled fecundity of
 Ma
with the self-contradictory vigilance and linga-show of Pa.
This work is a mystery. Be mysterious and innovate.
Everywhere and forever, time and place are how you perceive them.
How you perceive them is how you shape them.
How you shape them changes how you perceive them.
Hear Mother's drone and be silent before you speak.
Begin by asking for Her blessing, and you will do well."

Mother to daughter, sage to disciple, the lineages of the throat
 circle come to Earth.
Time passes and the sages speak of it. Time passes both outward
 and inward.
The noise of the outward world grows louder and louder.
The lineages break in two. Half turn in, half turn out.
The powers of the outward lineages over-resonate the quiet side.
Battling for control of the sound field, the loud sages say, "No
 mystery.
The truth of everything is relative to the truth of every other thing."
The quiet sages say, "For all that you say, this is true.
The Truth you can't speak measures these truths of which you
 speak."
The loud sages say, "Only God, if He exists, knows the Truth we
 can't speak,
if It is." The quiet sages say, "You are that One, but you have
 forgotten.
You listen to yourselves alone." The loud sages say, "Only blood
 speaks,
And fire, and metal, and power on Earth..."

The Mother of Fullness, consort of the birthless Sage, listens to the
 quiet sages.
In waters from the Himalayas, She comes down and they speak
 with Her.
She hears how, among Her grandchildren,

born from Her Son's body, many do not know Her.

The loud neo-sages do not speak with Her. They say to Her
 grandchildren,

"Everything is in parts. Make up wholes by your own powers.

Monopolize the Earth and everything you can.

Be encouraged. Be mighty and subdue."

Mother touches the feet of the birthless Sage as He sits in
 meditation on His mind peak.

"My Dear, there is trouble on Earth," She says. "Our loud children
 have forgotten Us.

They fill the Earth with themselves and their creatures alive and
 dead.

When You gave them the sound '*aham*, I, I, I,' was it Your plan

that, to quiet the enigma of self-knowing, they would have to
 destroy themselves?

Indeed, as destruction is in Our power, it is also in their power.

We alone, I think, with Son, are able to destroy their destruction.

Act after act, their violence escalates. They cannot stop themselves,

nor can they change their deeds, nor tell their knowing from not-
 knowing,

nor their power from their impotence."

The birthless Sage disagrees. "Let them learn by their errors. I
 warned them.

Before they were born, I instructed them. Let the thing go to its
 limits.

If You protect them, they remain ignorant.

Is it Your wish to keep them like children?"

The Devi says, "I shall give birth to Myself as an Earth daughter.

You give birth to yourself as an Earth sage, and we will show love
 on Earth.

Only love can outdo destruction."

The Sage says, "With the fire of my third eye, long ago,

I destroyed love. I burned that god to ashes.
My power is erratic. I can't be controlled by love.
It is your illusion and fantasy that love changes the way of things.
My way is freedom. My way is not to attach.
Your love does not change me. At my will, I can turn from it.
I can live entirely alone."

Devi bows to Her Lord's singleness of mind.
She knows He is stubborn and attached to His profound choice to
 ignore love.
Especially, He is forgetful of that most sublime divine energy,
 Awesome Upsurge,
Love's Fiery Desire, that arises from His subtle linga half-apart as
 if He were not sage.
He is not a love-knower and other-knower as She is.
"My Lord's linga and heart know this mystery His mind denies.
He forgets that My pretence is as His mind veiled in My cave,
and His desire is My most powerful illusion.
Therefore, I shall manifest on Earth, and He will follow Me.
I hereby extend my bridge between ante-tempus and birth."

II. Ma Bridges the Birth Fields

Ma practises quiet sitting, slow breathing,
centring in Her navel Her maxifull multiverse.
Abiding in Her Mother form, She generates Her waves' forms,
waves of Her Lord's mind, mother sea of what can be,
coming and going, ebbing and flowing, in and out, yoga breathing.

She uses Her spine as Her stick, Her inner serpent as Her rope.
She churns Her sea's milk, food of what can be.
With Her plus at the serpent's cloudy tail and Her minus at its
 fiery head,
She churns back and forth. Out of Her ocean floats like butter
the red-gold luminous nectar, Her immortal abiding.
The Medicine God floats up and catches the butter in His butter
 pot.
Sri Beauty floats up on a lotus flower pedestal,
a white lotus whose nature is to eat from Ma's sea and shine in Her
 light.
Blue-black poison floats up, and now comes Her Lord to drink it
 up.
He cannot die of it, He can take the toxin in, He alone.
Stirred up too, Son awakens from His sleep on Her milky sea.

Having eaten Her red nectar, having received the light of Son's
 awakening,
having reflected in Beauty, having shuddered at what Her Lord can
 do,
Mother clothes Herself in the form of a mortal, beauteous Sati,
daughter of Daksh the Smart, he who perpetrates clever acts from
 false knowledge,
Daksh who misguides the lineage born from Son's dextrous hands.
Abandoning their duty as speakers of wisdom to all born of Son,
the loud neo-sages misguide Daksh to make tools for deadly power.
Ma enters birth to overpower this power of Daksh.

In Sati's form, She will defy Her arrogant father.
She will arouse Her Lord to diminish Daksh.

In Her birth dream then
Ma touches the blue throat of Her Lord, where the poison He
 drank lies.
She can feel His mystery in Her fingers.
His form of love is compassion, salvation from the poison churned
from the waves of His mind, the waves which are Her.
"What none will carry," she feels His throat say,
"I will carry and not let go.
I am not attached to love or life. I am free. I cannot not be.
I will carry the dead and the deadly.
I will carry what Daksh disdains, what Daksh excludes.
I will carry Daksh, even as his heart shrinks and hardens,
and his mind is stuck on power, and I overpower him."
Her Lord will not speak this. He will not flaunt this.
It is His mystery. She feels it. She is sure of it.

"Beloved," She dream-speaks, "I now begin Our first earth-birth
 stories.
What happens cannot be fixed by one story.
Therefore I will tell how I both died and did not die,
how You both raged and did not rage,
how Daksh was cursed both to die and be retold reborn,
and how people both learned and did not learn from Our stories.
As my boon for reminding You of these tales of Our Earthly lives
in the birth-dreams when we were clad in Our exterior evolutes,
please reciprocate thereafter with Your subtle awakening discourse,
how We are each One Another."
Thus dream-saying, Ma projects their first incarnate relationship
onto the field of earthly forms. This is in the first age when
 humans' hearts hardened.

This is the on-droning of Mother Sati and Daksh and the children
 of Son's hands

in that gone never-gone age.
Daksh and the monopolists of handy work stud themselves with
 aggressive tools.
To contradict them, Ma takes on Sati's soft loving form,
her nubile adolescence in love with the birthless Sage.
Daksh offers lavish sacrifice to Son. Whatever Daksh wants, he
 asks Son for it.
Not at all does he recognize Sati's beloved as primal Pa, progenitor
 of One Son.

Sati makes adoration to Dam-Drummer, Pride-Seeder, Linga-
 Flaunter, Love-Destroyer,
Spirit of Contradiction, Poison-Drinker, Corpse-Carrier, Demon-
 Tamer,
Primal Sage, Primal Yogi, Primal Dancer,
Self-knowing Self, known to Himself alone.
She makes Him an illusory wild jungly form designed to offend
 Daksh,
a form Daksh can't begin to grasp with his craft of mind or hand.

"Father," says Sati, "this great God, Lord Shiva, Whom I hereby
 form and name,
He is My eternal true Beloved. Do not be put off because He lacks
what you invent to be right for your son-in-law.
Accept the limitations of your former priorities.
Do not fear what you cannot control.
Take My Beloved into your heart, as I do into Mine."

Daksh is disgusted. "How can you choose such a linga-flaunter,
such an uncivilized disorderly partner?
The nature of things is wild; it is up to people to tame it.
Your Shiva cultivates wildness! Evil originates in wildness!"

Sati replies, "Father, you are misguided in your judgment about
 Nature.
I am Nature and Life Itself, and I know Myself to be tame and
 wild,

refined and free, mixed and pure; every possible degree is Me.
I am born to exceed your closed small view.
Let Me go to love my Lover, Lord of Freedom!"

Daksh mistakes his karmic forces for free power.
Rolling down-hill, out-of-control, he can't stop. He thrills at the
 high speed.
He can't see where the divine is invisible. He sees only his
 sacrificial fire,
his statues, his libations, his gifts.
He curses Shiva: "Offender of all things decent, gross pervert,
 ask for no share of my sacrifices.
Do not set foot across the boundaries of my property. Do not enter
 my sanctuaries.
Do not touch my civil domain. Do not touch my daughter
on pain of beheading and delingament."

Sati goes alone into the forest near Her father's palace on Ganges'
 bank.
She makes Shiva into the stone form of a linga-head.
She pours oblations over Him. Daksh perseveres against Her and
 Him.
He takes the linga-head and smashes it in a thousand parts.
He sends the shards far, far away.
She sets up a linga-like stone from the riverbed.
Daksh throws it to the other side, beyond his domain.
He calls for a sacrifice to purge Her evil love from his property.
A great fire is made and butter is poured on it. Mantras are spoken
to all the gods but Ma and Pa, to all the gods Daksh's poets hymn
for their radiant power, their opulence, whatever he wants.
The fire is high. Sati jumps in. She burns.
She performs the yoga of disincarnation. She bridges to the other
 side.

A quiet sage comes out of the woods to speak:
"Daksh, you will be reborn and re-exposed in your vainness.

Time and again, your daughters will be destroyed when they stand
 up to you.
In the last age, the Kali Age, will you still try to force your children
 to be like you?
Will you pollute people's water and corrupt their food?
Will you act with power ignoring your ignorance, or will you learn
 from Sati's truth?
Honour Nature, honour Life,
honour Nature's Lord, the mysterious unthinkable Dam-Drummer,
even as He beheads you."

In a flash of Shiva's lightning, Daksh's head is gone and his trunk
 falls dead.
His astral body, carrying all the subtle traces of his desires and acts,
hovers with its history unredeemed, its karma bound to choose
its next choice of body, human or demon, for rebirth on Earth.
Should it be perhaps among the petty, low, merciless and bloody
 gods
preparing paths of cruelty for the Kali Age? Perhaps among the
 low gods
can he achieve the most far-reaching delusions, monopolizing the
 mentalverse,
puppeteering thoughts in humans, demons, gods, plants, stones,
 animals, elements?
Can control of the most mind be usurped by the delusion power of
 a demi-god?

Daksh's astral head vows: "In my next birth, I will have ten heads!
I will dominate the worlds' head space!
I will have the most heads of all!
I will be the most in the mentalverse!"
That said, Daksh's astral body with ten heads
disappears into the womb of a demoness sleeping on a far-off
 island with a demi-god;
his chosen father's moiety is anger-power,
the alien moiety to Daksh is love-power—no balance in him at all.

But that is the drone's next tale.

Shiva gathers Sati's ashes. He sprinkles them around.
"OM!" he intones. "Homage to Ma in these dusts!"
In them Shiva clothes the naked form of body-image Ma made for
 Him.
"In My next birth," Ma says, "I will be Sita, born from a furrow's
 dust, and…"

"My dear, wait with Your birthly stories in the earthly field," He
 intervenes.
"Rest a while in meditational conversation.
Allow Your enemy to overdo his angry excess.
Pause Your narrative energy. Hold fallow Your multiplicity.
Allow Me to entertain You with awakening playful discourse."

"How esoterotic! Certainly I will pause.
Do put Your taut sleek gnomic words in My always open ear.
Let our conversation be aroused," appreciates Ma.

III. The First Eccentric Conversation, with Thatnesses

"I hereby begin the practice of deductible recollective gnomic speculation!" begins Pa.

"Begin it," agrees Ma. "Be comprehensively incomprehensible and eccentric at will."

Pa aphorizes: "Self-spun Conceiver, Yours is Our design!"

"Yes," She bows.

"Yours is the urge to project and reflect a multiverse!"

"It is," She bows.

"Yours is the distinguishing of Your reflecting from Your being reflected!"

Bowing again to His discernment, She responds,
"In Your so-conscious Self, Our multiverse reflects Self-knowing!"

"Yes," He agrees, "Oh Maya Shakti, Power of My Illusion! In Me each *jiva*, each unique experiencing soul self, reflects My mind-form,
My unique experiencing Self!"

"Indeed," She praises on, "oh Great Self Whom I name Shiva,
Whom I form as the One Who experiences Who You are,
You are the Master of My yoga that links each *jiva* to You!
Uncompressed in Your Self, compressed in each soul self,
You illumine, and know as truth, My illusion!"

"My Dear," says He, "hear now the true order of Our thirty-six thatnesses.
They unroll Our manifesting as You conceive them.
These are the *tattvas* remembered in My mantra '*tat tvam*, that you are.'
I place them, along with My *OM*, and including *ahamkar*, My I-maker, in each soul-self."

"Name for Me then," She requests, "Our thirty-six *tattvas*,
that I may take rest in Your practice of enumerative speculation,
Oh Master of peculiar conversation."

"My Dear, Our union is as a circle *O*, an empty zero and a nascent
 seed.
After that We come, the first Two, Me and You. As We are Father
 and Mother,
let us distinguish Ourselves also as Mind and Nature, Freedom and
 Energy,
Shiva and Shakti, linga and yoni, and consorts of all sorts," He
 distinguishes.

"Oh great Speculator," She inquires, "what then is Your vision of Us
as We reproductively and energetically Self-expand from two to
 five?"

"Still We are very pure," He establishes. "Nothing of Us is
 manifest.
All possibility is prepared. Remaining Ourselves,
We manifest three faces in the pure fields of the Overworld:
My ever-benevolent peaceful Self-knowing;
My Self-knowing of the universe as Myself;
Your Self-knowing of the universe as not itself-knowing.
Out from these, Our three faces of pure knowing,
You Self-manifest as Maya, art and craft of Our making,
And make the *alamkars*, Our infinite decoration-makers."

"So it is," She agrees. "As the tissues of an embryo evolve,
 decorating,
veiling each incarnating Self, I manifest Self-veiling, Self-
 decorating.
I increase enumerative knowing."

Pa enumerates, "These are Your five thatnesses:
extravagant detail; knowing detail;

desire and delight in knowing detail; time in sequence;
restrictions of all things to their places and causal orders."

Ma affirms, "Thus begin the Earth fields and birth fields.
Into them Our Perpetual Birthful Incarnator Son is born!
My Dear, You have mirrored, in Your blissful speculation,
the vital process of My birthful womb."

Pa concludes, "From Your matrix there expand
buddhi, ahamkara, manas. These are waking-maker, ego-maker,
 thought-maker.
Then five sense organs, five action organs, five stimuli of sense, five
 gross elements.
Here in all are Our thirty-six thatnesses abstractly accounted for as
 promised,
oh Lady evolving true illusions and enumerative knowings!"

"Lord of philosophical speculation, I am well-rested by this, Your
 abstract accounting.
I now emerge from these Your subtle inner to My gross outer
 thatnesses.
Veiled in Our myth of divine consorts, I hereby incarnate as Sita,
wife of Ram, Perpetual Birthful Incarnator in the age of Daksh
 retold
reborn as Ravana, ten-headed mighty son of demoness and demi-
 god.
Do You then incarnate for our son Ram Your adorable jungly
 animal aspect.
Take birth as Hanuman, humble monkey hero, and be Ram's most
 powerful devotee."

"My Devi, I have no form in all my fields more humbly heroic than
 Hanuman,
no appearance more delightful for Me to call into Your service,"
replies Pa. "Let Your Sita unfold."

IV. Ma Re-embodies from Her Dust and Ashes in the Earth Fields

It's long ago, four centuries short of three millennia.
Ma's starry belt revolves its change for us on Earth, from Ram to
 Fish,
from generation to regeneration. So now
She cycles Fish to Waterpot to vivify us, if millennia be to come.

But in Her non-material thatnesses of waking, ego, thought,
 ensouled in living beings,
also in me, our conscious ages feel themselves through fluctuating
 moods and judgments,
undulating plus and minus, hope and fear, respect and hubris,
adoring and oppressing Her on Earth and in our nature.
Demi-gods and demons agitate our web of souls, but no soul dies
of its own or others' evil. Long is our course of error,
long our learning, slow our knowing, deep our droning.
Again and again, Ma heaves and works to stabilize the heaving,
 show slow knowing.

Thus to save our world from demi-god demon Ravana,
hubris-king in that gone never-gone age,
Earth Mother gives Self-birth as a baby girl. Her birth-womb
is a furrow in a field near Mithila, capital of Videha.
Simultaneously Birthful Son, wearing a hero-form as his vehicle,
emerges from a human womb in Ayodhya capital of Kosala,
a kingdom not far away, to the north, up the Ganges.
Ma takes the name Sita, that is, furrow, and Son the name Ram,
 darkly pleasing.
Simultaneously, to the south on the island of Lanka,
Ravana's ten heads lead his way from a demoness' womb.
Meanwhile Father sends His form as Hanuman
via Wind Father into Anjani's monkey womb.

Sita's adoptive father, King Janaka of Videha,
falls in paternal love with Her as adorable bambina
the moment he sees Her curled up there like a jewel in a cabbage
head.
Why did Sita pick Janaka as her adoring father?
Janaka is a quiet sage and devotee of Sage Pa. He likes to wax
cryptic.
He prefers thinking to acting, meditating to sacrificing, conversing
to commanding.
He neglects reproducing and provides no son for the benefit of his
ancestors.
His paternal forebears, nomads riding their horses with a
wanderlust wider
than all the steppelands of Asia, crossed the Hindu Kush and
Indus into India.
Near the Indus, they found peculiar horseless humans, men and
women
sitting quietly under trees. Having fallen short on women, always
curious of new things,
they intermarried; deep-looking earthy native and conquering
restless folk
mixed it up. Moving on to the east with growing families,
Janaka's mixed forebears reached Ganga and crossed to Her other
side.
Tree-sitter ways modified nomad ways. The families settled down.

Janaka has, from his mother line, a sagely longing toward his inner
Mother space
fructified by knowing it. Always he gravitates to the woods.
There bark-clothed yogis and yoginis, turned toward inner fullness,
sit under trees.
"OM," they intone, "OM NAMA SHIVAYA." Their soul selves
reflect Sage Pa.

From Her residence below appearances,
noting that in life every strength has a weakness attached to its
other side

and the reverse is also true, Ma senses how Janaka forgets to
 ritually honour Her
as the ground on which he walks and sits, from which his food
 comes,
which receives his wastes, to which his earthly body will return at
 its death,
and in which the divine becomes incarnate. His ritual space is
 entirely inside him.
 "I shall give him Myself as a girl child," Ma resolves.
"Then he will remember the life cycles and rituals webbing him
 inside and out,
and know that Sage Pa and I are an inseparable One."

Around Janaka's city are fields; beyond them are woods.
There the quiet gurus of his kingdom live apart in bark huts and
 bark clothes
among their milch cows and the cottage gardens their wives tend.
Janaka is en route to his guru when he finds babe Sita in the
 cabbage plant.
She is dark as the dunged soil. Her newly-opened eyes
are like Earth Herself watching him, and Her cry like Earth's cry.
Immediately as he wraps Her in his shawl and cradles Her to his
 breast,
She takes comfort against his warmth, his heartbeat, his breath
 hum.
Stroking her little back, holding the little multiverse of Her, he
 returns to his palace.

Hearing of the baby miracle, his guru pays a visit.
Janaka rises from his mat where Sita lies swaddled beside him.
"*Namaste*, oh bark-clad one," bows Janaka. "Direct me in my
 fatherly purpose."

Guru Yajnavalkya, whose guru is Sage Pa, is a yogi of essential
 mysteries. He begins:
"Oh king, just as, wishing to go a long way, you would take a
 chariot,

so, wishing to reach truth, you hear wisdom and take *OM* as your
 mind-vehicle.
But where will you go when you are free from these embodied
 envoiced things?
And from where does your daughter come into these embodied
 envoiced things?"

"Teach me, venerable sir," requests King Janaka. Yajnavalkya
 responds,
"Hear the secret physiology of the invisible incarnating birthless
 Person, oh king.
In your left eye the fuel, in your right the radiance,
in your heart the place of praising, in your heart the nerve-roots of
 your body,
in every direction the vital energies come and go.
The true Person is not this, not this.
The fuel and radiance enter the body, leave the body,
burn and shine. In the juncture of dark and light,
in the juncture of dream and waking, in the juncture of birth and
 dying,
the true Person, oh king, is not divided. That you are. That I am.
 That Sita is.

"When a body grows thin and worn, then as a mango, fig or *peepul*
is released from its stalk and tree, so is the Person released from the
 limbs
and, in season, returns wrapped in the traces of what it knows, what
 it has done,
what it has experienced. Hear this revelation:
'When all the desires in your heart are set free,
the mortal becomes deathless, you are One in your body here.'"

"Hereby I give you many cows for this knowledge!"
decrees Janaka. And so, attending to wisdom, Janaka nurtures the
 gift of Sita
without making desires for Her. He waits for Her to unfold

according to Her nature and purpose, not himself knowing what
 that will be,
only knowing Her to be immortal. And thus Sita grows
without forgetting Who She is, what Her task is, and blesses
 Janaka.

Meanwhile, up the Ganges from Videha, in the city of Ayodhya
 capital of Kosala,
a sonless king, Dasaratha by name, devotes himself to sage priests,
 law and ritual.
He is busy with these things and does not seek further wisdom.
Praying for a son, he vows to perform the greatest of all rituals, the
 horse-sacrifice.
His sage priests set it up. As they pour ghee on the fire,
Dasaratha sees, taking shape in the flames, a radiant god, Son pre-
 incarnating.
The vision says, "Dasaratha, in answer to your prayers,
here is *paayasam* milk pudding. Give it to your wives in portions
 due their honour."
So Dasaratha gives Kausalya, his first wife, half the pudding,
of the rest half to the second, Sumitra,
of the rest then half to Kaikeyi, his favourite, most beautiful, most
 young,
and again the last draught to Sumitra.
From her portion Kausalya bears Ram, Sumitra bears twin sons,
 Kaikeyi bears one son.
Each son manifests Son in the due proportion of his mother's
 pudding draught.
They manifest through their virtue. They are perfect princes,
acting always according to law and for the good of others,
though Whom they manifest does not reveal itself altogether in
 their memories.

According to the timely purposes of their incarnate natures,
their keen desires arisen upon meeting,
and the astrological match-making of Dasaratha's sage priests,

Ram and Sita, having grown up, marry. Janaka dies.

Dasaratha grows old and prepares to crown Ram his heir.

But his favourite wife has as a confidante a Ma-appointed mock-
demoness.

Disguised as a hunchback, she provokes agitation in the favourite
wife's vain mind:

"Listen to me, Kaikeyi.

If the King crowns Ram as his heir, Ram's mother will have power
over you.

She hates you because you're the King's favourite.

Remember, when you followed him in battle and saved him when
he was wounded,

he gave you two boons. Ask for those boons now. Say to
Dasaratha,

'Crown my son king. Send Ram into exile for fourteen years.'"

Miserable Dasaratha feels himself bound by the law of boons.

Because in his ignorance he committed himself to Kaikeyi,

he feels forced to act against the desires of his heart.

Ram and Sita go into exile. Dasaratha does not know Them to be
immortal,

does not know how the exile is Sita Ma's divine plan,

does not know that the immortal Person, not the father's lineage,

defines nature and purpose. Still in ignorance of these immortal
truths,

clinging to crossed desires, deprived of his beloved son, Dasaratha
dies of a broken heart.

Carrying his karma with him, he dreams his next paternal birth-
path from the other world.

There drones louder now the birth and maturation of ten-headed
demon Ravana.

Sage Pa has a son, Pulastya, an ascetic yogi, born from His mind
fields.

Pulastya practises austerities and begets a son, Kubera, on his
female side.

Kubera devotes himself to Sage Grand-Pa as One with Devi Ma, Who

appoints him leader of the guardians of Her Earth's wealth, of the lower regions,

of darkness and subliminal beings, ruler of Lanka, kingdom well-populated

with gandharvas, yaksas, kimpurusas, rakshasas, demi-gods and energy sprites,

Earth scents and sounds, dryads, naiads, elves and dwarves, fiends and night-demons.

Angered jealous Pulastya creates a new self and begets a son, Visravas, with his half-self.

Visravas, fierce yogi demi-god, hates Kubera, to whom he is permuted father-brother.

Kubera moves to assuage Visravas' hate with a gift of three Lankan demonesses.

Each demoness, producing every illusion of female grace and art,

arouses Visravas' boon-granting powers. Each requests, "Great Sir, fill my womb!"

Potent from austerities done, in anger without love, Visravas

begets five sons on those three demon wives whose charm is illusory.

Ravana is the eldest, the most mighty.

Exceeding even his father, he does extreme yoga and gets extreme powers.

He too renounces love and thinks he commands nature,

thinks he rules the order of what can destroy him.

He can instantly grow back his heads, arms and feet whenever they're cut off.

He can multiply limbs and grow demons from his blood drops.

He wins a boon that no divine being can defeat him. Only a human can defeat him.

He scorns any need to defend against humans. He eats their paltry flesh.

Changing form at will, flying through the sky, he attacks Kubera, defeats him in battle.

He usurps Kubera's kingdom on the island of Lanka.

He enslaves the guardians of Earth's wealth and of low, dark and
 subliminal regions.

He respects nothing of Earth and life, only his own possession of
 wealth and power.

Some demons of Lanka accept and adore him. Others watch
 powerless in terror.

Kubera curses him: "As you have shown me, your elder, contempt,

you will soon cease to be! Your illusions have not pictured their
 own delusion!"

Fleeing with a small band of Earth-guardians, discerning demons
 and subliminal beings,

Kubera sets up rule in exile near Sage Pa's Himalayan peak.

Ravana's extreme power expands itself northward.

Tuned by yoga to the astral and mind fields, he detects that Sita
 has incarnated Earth Ma.

If he can own Her, if She will be his consort, He will rule all
 material and divine beings!

He will manipulate every body, mind and soul!

He must have Her. Her paltry husband Ram is a mere man.

Ravana cares nothing for astral rumours that Ram is half-Son,
 half-man;

such a condition is ridiculously low, beneath Ravana's notice.

Pride, power, greed, and ignorance stuff his ears. He will have what
 he will have.

Meanwhile Ram and Sita, living exiled in the forest,

living amidst the quiet sages, listen to the forest sounds.

Creatures are speaking, telling of Earth's plight, the rise of Ravana,

the imprisonment of Earth's seeds, the replacing them with demon
 seeds,

the death of birds from poisoned foods, of fish from ruined waters,

the low-sinking of ground from the rape of Earth's minerals.

As they listen, Sita sees a golden deer with jewelled hide and
 antlers.

"Follow that deer, Ram!" She cries. Surely it's the demon king's,
surely it's bad magical. Why does She want it for Her pet? Why
 does She ask for it?

Ram knows, in the nature of cosmic love, there is union and
 separation;
in the nature of divine power, the steadiness of truth and the play
 of illusion;
in the nature of incarnation, peace and war.
Thus according to the timely purposes of their incarnate natures,
Ram leaves his beloved Sita and the quiet sages' hermitage.
As contrived by Ravana, the deer illusion leads Ram far away.
In the guise of a hermit, Ravana comes to Sita's hut.
Seeing Her alone, determined to have Her, he flashes
his mighty ten-head form and grabs Her with twenty arms.
Flying Her in his grips to Lanka, his heads think he has Her,
but too many heads do not know what is not destined to be
when they occupy themselves with their wills alone.

Sita Ma looks down as Earth passes below Her.
In the south, over the kingdom of monkeys, She lets fall Her
 yellow shawl.
Pa as Hanuman the monkey awaits His duty to help Ram find Her,
to free Lanka and the world from the demon with ten heads.
Sita will destroy Ravana from the inside as Ram kills him from the
 outside.
From the secret reservoirs of Her Mother forms, She will reveal
 Bhadrakali ,
Her invisible illusion more terrible, more true, than the illusions of
 bad demons.
That form arises, She releases it, when a demon reaches his limits,
when he exceeds what he can control by illusions of partial as total
 power.
Then his usurpation collapses upon him, and She ends the cycle of
 his domination.

The sight of Her flying by in Ravana's grips arouses Her creatures,
birds, monkeys, trees, stones. Birds find Ram and cry to him:
"Ravana has seized Your Sita, Ma's own incarnation!
She appoints You to make league with Hanuman the monkey-man.
We have seen where She has let fall Her yellow shawl among them.
We will lead you to Hanuman!"

Mysterious variances are in Ram's half-Son form.
Subtle questions arise which I for one cannot answer.
Does Ram have human mortality, but not human error?
Or does he, being only half-Son, only half-remember his divinity,
only half know he can save Ma? Was he deceived,
thinking to please Her, to chase the deer and abandon Her?
Does his man-half believe She is lost to him forever, raped by
 Ravana?
Will he fight Ravana to the death, but not to win Her back—
will duty, lawfulness, and valour out-place love for a wife touched
 by another man?

Ravana locks Sita in a garden, a place of pain disguised as pleasure,
well-guarded, deep in the bowels of his palace.
He showers Her with showy demon things without love or
 freedom.
She has one year, he says, to accept him; then he will eat Her.

Sita Ma practises quiet sitting, slow breathing,
centring in Her navel Her maxifull universe,
centring in Her navel even this hell disguised as paradise,
even these bad demon powers, even Ravana.
Thinking She cannot escape them, they cannot escape Her.
Using Her spine as Her stick, Her inner serpent as Her rope,
She arouses the nectar and poison from Her inner sea.
Ravan smells the nectar, wants the nectar.
She drinks the poison, the dark blue essence of Her Bhadrakali
 form,
and prepares for the day when Ravana will exceed his illusions, the
 day

when Ram, fighting his way through the enemy demons, will reach
 Her.

Will Ram deny Her his love because She was in a demon's grips?
A Goddess, incarnate where men rule, is vulnerable to men's
 judgments
and can be disowned by them. For these trials, Ma prepares
 Herself.

Sita's demoness guardians and handmaids worship Devi Ma.
As devotees, seeing Her in Sita, secretly defying Ravana, they tell
 Her
how Her Ram, with Hanuman's army of monkeys, attacks Lanka.
 Daily they tell
how the war goes back and forth. The demons use magic weapons;
Ram, Hanuman and the monkeys use ethical weapons. The battles
 are terrible.
How can I imagine, on each side, the powers, the destruction,
the heaps of dead warriors, the blood-soaked, weapon-studded
 Earth?
I am closed in the women's rooms, in the centre of the palace.

To Sita Ma, after the sun sets on the thirteenth day,
Ravana comes in from the battle, all his sons and warriors dead;
 again and again
his amputated heads and limbs regrow. Determined to hold Sita
 forever,
he stimulates his will to wield magic in battle, to get demons from
 his blood drops,
to march out one more day. He has the boon that no warrior can
 kill him.
His heart is hard and invincible.
He has lost all his sons and siblings, all his natural blood relatives.
There remain only the demons grown from his blood drops.
But locked within his heart now there is a mote of pain,
a pain of love. The dear image of one of his sons, now dead, is in
 his heart—

that dearest one of his sons whom he wished would inherit and
exceed all he has.

That pain, that bit and mirror of himself broken, causes the
hardness of his heart to crack.

In that cracking, Ma takes Her invisible Bhadrakali form, Her
most terrible Mother form.

This form has the heat of a thousand sacrificial fires. It makes a
desert of life's waters.

It collapses the brazen self. It turns illusions into ashes.

At that cracking moment, Ram's arrow strikes Ravana in the centre
of his heart.

V. Pa Pauses Ma

Having conquered Ravana, rescued Sita, and completed his exiled
 years,
Ram returns to be king in Ayodhya. Royal law binds him:
he must do what is right for his people, not for himself alone.
A king's marriage must have no flaw in it.
In divine love there is truth first; in human politics there is law first.
Rumours arise against Sita, that She was in a demon's hands.
Though She walks unscathed through fire, proving Her honour,
law and rumour stand against Her. People are suspicious.

Does Ma open a furrow in Her Earth? Does She unmanifest Sita
 in Earth's embrace?
As half-man, does Ram rule alone? Or do Sita and Ram live
 happily ever after,
can law and love be one in that gone never-gone age on Earth?
Among such alternatives, the drone of history is malleable and
 obscure.

Out of whichever present that time was, Ma foretells to Pa what's
 next to come round
in the history of incarnations:
"Son dying as Ram will manifest as Shyam when
from Ravan's astral blood-drops, as from dark eggs, will be born
 more troubled men.
Not honouring Me on Earth, they will drain Me and trample Me.
They will cover me with their products. They will assess me as
 money.
Weapons will be their art. Their skill will be killing.
Not honouring You in them, their minds will have no peace.
Sage Lord, give discourse.
Quiet My grief over what will be in time's dark course.
Make Us a pause between troubles."

From His undauntable yoga pose, Pa pronounces:
"My Devi, the life pause ritual practice is both secret and well
 known.
Its ways are unique for each time, place, and person.
They are also timeless, placeless, and shared by all.
Be initiate in its mysteries."
Ma responds: "I am initiate. They are in Me. Initiate Me."

Pa continues:
"Make the composing ritual. Make it
in the four corners of the Earth fields,
in the four corners of the soul fields,
in the four corners of the mind fields,
in the four corners of the bliss fields,

"to the East, in the dawn and in spring,
to the South, in the day and in summer,
to the West, in the sunset and in fall,
to the North, in the night and in winter,

"in the three worlds from up to down and down to up,
in the five elements from earth below, through water, fire, air, to
 ether high,
in the seven energy wheels and the energy channels netting every
 inside and outside,

"in the outer eye, ear, nose, tongue, and skin,
in the inner eye, ear, nose, tongue, and skin,
in the foot, legs, body, arms, neck, and head."

Ma responds:
"I make the composing ritual.
I am doing this doing."

Pa continues:
"In the four corners of the Earth fields,

in the four corners of the soul fields,
in the four corners of the mind fields,
in the four corners of the bliss fields,
to the East, in the dawn and in spring,
to the South, in the day and in summer,
to the West, in the sunset and in fall,
to the North, in the night and in winter,
in the three worlds from up to down and down to up,
in the five elements from earth below, through water, fire, air, to
 high ether,
in the seven energy wheels, in the energy channels netting every
 inside and outside,
in the outer eye, ear, nose, tongue, and skin,
in the inner eye, ear, nose, tongue, and skin,
in the foot, legs, body, arms, neck, and head,
the old wars calm, the wars calm, the wars calm.
The fields lie in peace.
The directions lie in peace.
At peace are the elements, energies, experiencing forms, and doing
 forms.
The centre inhales. The centre exhales."

Ma responds:
"My fields lie in peace.
My directions lie in peace.
My centre inhales, my centre exhales,
My centre is calm, *OM*."
Thus pausing, They *OM*-drone.

VI. Ma Manifests as a Voice and Survives Being a Battlefield

Ma's stories flow like Her Ganga from Her pausing drone.
Her embodiments come to Her Earth like Her raindrops from Her
 karmic clouds.
Among all Her stories in their rushing streams and tributaries
to which She appointed long-winded narrators with memory
divine beyond the spans of ordinary humans,
none drones more long than the one I am about to tell briefly
since my skill is short within the human span,
time is shorter than it was before,
and we're in a hurry through the Age of Kali.

I breathe a little longer and a little slower, but not much.
I sit by Ma Ganga and listen to the Mother-*OM*.
I sit by Ground Zero and hear the silent cries, the silent screams.
I do my business as the world cries, the world screams.
I am calm and quiet. I am angry. I am filled with fear.

Behold the gone never-gone time when the world joins in war and
 some against war.
Behold when the outer fight over-manifests the inner fight.
Behold patterns in the way things are.
Long ago it was when peace rites failed and tragic tales began.
I read 4500 pages in four volumes, 100,000 stanzas,
words fifteen times the Bible's, how there began and was fought
the ancient war at Kurukshetra, retold in ninety-eight hours of
 drama on TV,
a vastness like all the air of the atmosphere from which I sip
 breath.

To Kurukshetra came Son as Shyam aka Krishna,
and sage poet Vyas, devotee of Sage Pa and Devi Ma,
and heroes and heroines born each of a true god,
and there was Mother Earth on Whom and for Whom the fight

was,
and She is here in what I hear and read.

Mother tells Vyas the ancient Earth-war story inside him and
 outside him,
the enigma of the teller and the told,
how the teller begins remembering on the inside,
remembering how past history accumulates, how in the order of
 things
each act shapes time and time shapes each act good and bad.
Vyas sees in one vision the long history of his family,
the demands and powers of the fathers and mothers,
of the ascetics and the celibates, of their mighty oaths that can
 never be taken back,
of the influences of gods and demons,
of forbidden war acts that can't be taken back and destroy
 everything.
All of this is as it was and is and will affect us.

Vyas' grandsons are the cousins who fight the great war,
the heroes on both sides. The side that is good
is led by a king who seeks self-knowledge, law and wisdom,
who disdains greed and anger. The side that is bad
has leaders driven by desires, grievances, discontents,
men whose minds are fixed on untrue self-views,
who call on the gods for what they want
but don't accept the messages of FatherMotherSon they don't want.
Each hero good and bad has strength and weakness, good and bad
 acts.
Incarnate Son is a friend of the good king side and charioteer of its
 bow-hero.
He is a member of the royal class whose purpose is to protect lands
 and people.
Ma shows Vyas all that Son knows about what He is to do
to help the world when war can't be stopped,
how He acts to preserve survivors who'll remember law and truth,

who'll justly rule Her Son-born people and Her Earth,
though Earth's enemies briefly die and then re-multiply their
 incarnations.

Ma speaks to Vyas in two forms, tight and loose.
As all matter and energy expand from one grosser bang,
so words and thought expand from Ma's subtler *OM* in tight and
 loose knots.
In the tight form, Ma ties the knots of word and thought so close
that only sages and deities can penetrate them.
The tightness is like the tightness of a sutra thread,
like the compactness of an unsprouted seed with nourishment
 packed
to feed the germ of each idea able to multiply
upon being sprinkled or unspooled, multiplying without end.

Vyas is a rishi, a poet seer, a Brahmin sage, a yogi, ageless old.
If he were to be violent, it would be a sin for him. He carries no
 weapon.
Yet in the nature of loose things no one can avoid all sins and
 hurtful acts;
each must suffer.
As a yogi devotee of Sage Pa and poet listening to Devi Ma,
Vyas hears who he is and begins his loose story told long, which I
 will tell briefly.

From a secret tryst between a wandering hermit
and a fisherman's magical daughter, a girl born from a fish, Vyas
 was conceived.
The hermit promised the girl he'd take away her foul fish smell.
Thus Vyas was born, and his mother was sweet-smelling.

A king fell in love with Vyas' mother.
Her father (Vyas' grandsire) made the king vow succession for a son
 of the marriage.
Crown Prince Bhisma, son of Ganga, the king's first wife, swore a
 great vow

never to rule, and to live celibate all his life without issue.

The king's son by Vyas' mother was made heir, but was feeble and
died without issue.

Vyas' mother approached him:

"My son, you must act in the place of your half-brother.

Impregnate his royal wives." Vyas was a hermit

not cleaned, fancy or perfumed as a king is. Like his father, he
wore a single cloth

over his body which he caked in ash and mud. At the sight of him,

the first wife closed her eyes; she received sperm for a son who'd be
born blind.

The second grew pale; she received sperm for a pallid son.

The two sons grew and were married. The rule went to the pallid
son.

Though older, a blind man can't be king.

The blind son fathered one hundred sons, makers of trouble, on one
wife,

all born in one mass immature to be divided and gestated each in a
ghee pot.

The pallid king's seed got cursed when he shot two gazelles in love.

The female gazelle spoke these last words:

"You struck me and my lover in the sweetest of moments.

That moment of pleasure is to be honoured among all living beings.

Your violence exceeded the natural bounds of law.

Therefore you will die if you seek the sweet moment with your
wives."

The king abjured weapons and retired to the wilderness.

He gave the rule to his blind brother, though a blind man by law
can't be king.

As a boon for serving him, a sage had given a mantra to one of the
pallid king's wives.

With this mantra, she could call down a god and have a child by
him.

The pallid king's two wives mothered five sons from divine spirit
seed, not the king's,

and thus it was that Vyas' grandsons by his pallid son were born of gods.

One spring day the pallid king succumbed to desire for sweet pleasure and died.
The younger wife chose to die on his pyre, the older returned to court with the five sons.
By law the eldest, when of age, was to be the throne's heir.
But the blind king wanted the throne for himself and his eldest son.
Shamelessly the blind king's sons practised tricks and deceptions.
Their will was uncontrollable to get rid of the pale side and keep power over everything.
They exiled the five brothers for fourteen years.
When the five came back for their throne and their kingdom,
the blind side gave up nothing. They said, "Our way or our death!"
The five were forced to fight and kill every fighter on the other side.
The five lost all their sons.
Vyas' lineage was left but one surviving heir,
a great-great-grandson on the pale side.
For that one heir, Vyas tells the story of this war.

With eyes given by Ma, Vyas sees Son as Shyam.
He sees how Shyam rescued that unborn heir from its slaughtered mother's death.
He sees how the divine touches history. He sees how,
in the webbed womb of time ever-woven by Ma in splendid radiant patterns,
there is stickiness. There bundles up bits of history, tomorrow's food, and it is stuck.
On Shyam's blue-black body Her weblight shines.
Her peacock feather eye crowns His blue-black hair.
Everything happens in His darkness: there is peace, there is battle.
He is the size of a thumb in the heart's centre,
the size of the universe in Ma's womb.
He is the friend and charioteer of Vyas' grandson Arjuna the bow-hero.

He tells Arjuna how to fight. This is the most secret knot.
For each person, it must be untied in its own way.
It must never break its thread to Ma.
It must not be the provoker of animosity. It must touch the heart's
 centre.
When animosity arises, the Ma-thread roots the mind's steadying.

Ma tells Vyas, and Shyam tells Arjuna, how Time and Fate have
 Their course.
Every act will bear its fruit for good or bad.
Within the house of cards that is our history, destruction presses in
 from every side.
There is no escape, but there is knowing, seeing, truth in acting.

On his deathbed, still alive on a bed of arrows at the war's end,
Vyas' step-brother Bhisma, Ma Ganga's son, venerable with age,
speaks to the stained and burdened Earth returned at last to the
 just king's rule.
Following the umbilical through Son to His root in Ma, Bhisma
 pays deep homage
to the centre of the wheel of death cycling time's course.
He pays homage to Earth and Water, to Trees and Plants growing
 down and up.
He prays: "May our bloody sacrifice wash away our sin
and may this deadly cycle reach its end."

Why do we paint blood, an inner substance,
outward on ourselves and Earth? Is it because
poured blood reveals new life as blood in birth,
because those who can outlive their wounds establish a surviving
 blood line,
because of blood in food that saves from death by hunger,
because it enriches plants that save from hunger,
because the mind must imagine surviving the guilt in its memory
 of bloodshed,
because it toughens the mind to get tough to survive,

because our bond with blood is in the reptilian brainstem
from our heritage of brute power, like the dinosaurs', before words
 moderate us?
I don't know.

I know after red fluids, white ones follow.
After birth there pours Mother's milk and mothers' milk.
There churns Her cream to butter. There feeds Her yellow ghee to
 fire.
There tips out sperm-like moon-juice soma from the crescent
 cocked in Sage Pa's hair.
There washes in curd and foam His linga stone set up from Her
 river.
There scatters in the river and to the sea so many deaths' white
 ashes.
There scatters white chrysanthemum and jasmine among white
 lotus floating.
There snows and freezes in deep rest. There goes on.
There ascends Ma to Pa on His mountain peak—
Pa Who wears white ash on His skin and blood on His trident
 prongs,
Ma Whose skin is dark as Earth with a red cloth—
while Son sleeps, between His incarnations, on a sea of milk,
and their stories flow below like droning Ganga.

VII. Pa Makes Peace

Ma touches Pa's feet: "My Dear, may I enter Your mind fields
and request Your meditation to establish peace that is somewhere
 never gone
though elsewhere gone since war returns long?" Fulfilling Her
 desire
Pa tunes on His *dam*-drum the original 14 subtle *dams* with the 51
 linked undulations
and the waves super-vibrated. He mounts the prostrate form
of the demon of peace-forgetting and converts him to
 remembering
by the subtle *dams* on his spine's fluids en route to his cranium.
In a ring of fire from the war deads' pyres, Pa dances purgation.
He pauses and carries all the dead to the other side.
When the dead are all safely taken from their old bodies burned to
 ash,
He dances a cycle with 196 rhythmic measures.
From measure to measure, each step is exact and without variation,
and the number is sufficient so that no step is excluded or extra.
In Pa's audience are Ma and Son and Their vehicles,
Pa's old bull, Ma's lion, and Son's winged eagle, along with Son's
 sleeping couch,
Adisesa the Serpents' Lord. Son throbs in concert
to the rhythm of Pa's dance. He sinks heavily.
Adisesa can barely hold the sinking weight.
Immediately everything lightens at the end of it when Pa stops and
 sits.
Perceiving Adisesa's amazement, Pa gives Him the boon
that He will incarnate on Earth and record for mankind
three sciences revealing the peaceful practice of divine rhythms:
how to communicate, how to live healthfully, how to know the
 mind's nature.

On Earth below, an accomplished yogini named Gonika, a tribal

devotee of Pa and Ma,
is getting old. She prays for a suitable child to be her disciple.
Taking up some water in her hands to make an offering,
she closes her eyes in meditation. From on high, Adisesa sees her
 wisdom.
He opts to enter birth from her hands in the form of a wee snake.
When she opens her eyes, He takes human form, bows, and asks to
be her son.
She names her son Patanjali, "who fell into my praying hands."

FatherMother teach Gonika and Gonika teaches Patanjali
the nature of original co-vibration and the consciousness thereof,
how the weight of the delight of the dance is made light
by the discipline of yoga practised by Pa, Ma and Incarnate Son,
a discipline precisely summed in 196 verbal measures
matching 196 biorhythmic measures
preceded and accompanied by 196 measures of mental vigilance.
Establishing vigilance, Gonika says, "My son, sit and observe your
 mind keenly.
Write down what you see. Do not write down what I say.
Check out the truth of these measures. Knowledge must be tested.
Record practice and process. Keep it vital, not stuck or brittle.
Make manifest your uncut nutritious umbilical to the calm mind
 sea of milk."

Patanjali, incarnating Son's couch, records in precise detail of 196
 sutras in 4 books
the yogis' rules of awareness transmitted in Pa's primal *dams* and
 Gonika's instructions.
A discussion arises between Pa and Ma over celibate restraint of
 sex in sutra 81,
rule 30 in book 2.
For the darkness and suffering of life on Ma's Earth made some
 yogis say—
and is Patanjali among them?--
that She is a seductress, that She fills the mind

with illusions of pleasure which lead in the end to pain and death,
that these illusions must be left behind if the mind is to be free of
 pain,
and particularly must be abandoned the illusion
that women and children are to be desired,
for what is to be desired is freedom from rebirth.
Pa says, "Ma, I know I'm a bad example
since for thousands of years I withdraw to My peak to meditate,
but still in meditation I receive homage and hear prayers,
and for thousands of years My linga and I are Yours to love,
and You are always My eternal Half, and I am Yours,
and with You are all that is and all My people.
Are these new yogis misleading My people and causing them to
 doubt the worth of life,
and so imbalancing the world with dim views against life itself?
Has our Patanjali fallen among them?
Has he lost the women's wisdom of his mother, given by You?
Has he lost her tribal link with Earth, given by You?"

"Rest assured," replies Ma, "the world is properly as imbalanced
 and excessive
as You appear from reflecting it on the left and right
sides of Your clear balanced and measured peaceful mind
which is never gone and allays all doubt. There are yogis of many
 kinds
within Earthly fecundity, and about My illusions there is much
 play of illusion.
The problem is not in sutra 81, well *dam*-drummed by You
and recorded by Patanjali incarnating Adisesa, Son's flexible couch,
to mean a yogi is to be focused, not scattered,
as all a yogi's acts are to root in one-pointed focus
wherein non-conflicted equal mind is practised with ardour and
 vigour.
Around such a yogi are generated mind-waves slow and quiet, the
 waves of peace.
In quietness a yogi knows when and where to be solitary, conjugal,

or sociable.
Our devotees, taught by Patanjali and Gonika, are such as these.

"After 4 billion years evolving life and mind on Earth, though
 ageless, I am growing old.
As a battlefield, can I go on forever? The point is,
to further peace for Me in minds' and Earth's fields as I requested,
Your first imperative touching restraint in 81 is ahimsa, restraint of
 violence not of sex.
Ahimsa disciplines the sexual, appetitive, competitive, vegetative,
 agitative, cognitive,
intuitive, manipulative, demonstrative, compulsive, karmically-
 loaded subtle body nexus.
Then love and peace and comprehension load in the disciplined
 nexus."

"Devi," dams Pa, "You've reassured Me. Let there increase, in life
 on Earth,
non-violent thinking, speaking, doing.
Let's dance the corresponding measures.
Though I'm no poet as You to speak of love,
I philosophically declare the desire of all things for ecstasy in
 union.
Therefore let everything but union be unreflected
in the heavenly earthly practice of sutra 81, one-pointed focus
with non-violence, self-knowing truth, and non-possession,
as it connects with all sutras and each is all in one.

"In on-going embodied practice of Our Patanjali's yoga rules,
or one yoga rule or some quantity of rules to the extent of each
 person's capacity,
let there yoke the oppositions split in carnate minds
between spine-stem and brain, between signals autonomic and
 voluntary,
between lower and upper spheres, between left and right camera,
between thought and body, between self and world.

Let there evolve whole persons.
Let there mirror in manifold the shape of Son from Your womb.
Let there be honoured and consulted such ones on Earth.
Let such ones be imagined and empowered in human eyes."

VIII. I Bathe in Ma's Rivers

Ma and Pa dance their duo of 196 biorhythmic mental-vigilant
 measures.
From below Their love peace peak, in the world of worse dreams
a cry goes up from Their yogis and devotees, me among them:
"We sit beside Your rivers, under Your trees,
on Your mountains, in Your caves, beside Your food plantings,
in Your cities. Big saws are cutting Your trees away.
They are laying Your mountains bare. Factories and dams are
 polluting Your rivers.
Big food crops spoil Your plantings. Drills and mines pierce Your
 body.
Everywhere people attached to their machines overpower us.
When we sit in trees, they come with saws.
When we move far away, deep in woods or desert, high on
 mountains,
they take over our refuge. We are few, and they are many.
Our power is Your creation, theirs is their creation exploiting Yours.
Our internal refuge is in You, but what of our external refuge with
 You on Your Earth?
Are we humans doomed to destroy Earth and ourselves upon it?"

Pa replies: "Restrain in your minds these prophetic anticipations of
 apocalyptic futures.
Activate yourselves to present vigilance.
In all of time, in small, middle, and large degrees,
I bring bodied beings to disconnectings and dispersings
and return them to connectings and unitings.
Initiate wisdom calmly with this non-illusion."

As we grow slightly calmed by Pa's wisdom of non-illusion, Ma
 speaks inside us.
"My beloved, as Rivers, Trees, Mountains, Herbs and Flowers,
I come down from the mind fields and the bliss fields.

142

I bud Nature from My Earth body.
Within My Nature are violent humans deluded in their wills to
 conquer and exploit Me,
deluded not to live in friendliness and understanding with Me.
I can't turn their wills from their love of their machines powered
 against Me.
Humans are free to seek My divine wisdom.
Among My Nature's multiple vicissitudes
change happens by cumulative force of actions in the course of
 time.
Therefore accumulate a force for peace through meditation, speech,
 and healthful living.
The evils of which we speak bear their own undoing.
Take internal refuge. The life seed is a faith seed.
Let it grow inner force and multiply outwardly on Earth.
Take courage and grow peace from faith.

"In your rivered veins, in the river Ganga and all rivers,
in the veins of plants, animals, and Earth's body,
I flow through Heaven, Earth, and Death's seven layers
where life goes under with no view of Heaven.
If you bathe in any of My internal or external Ganga forms,
you will hear my Ganga story."

I bathe where the waters come down at Rishikesh,
where they come down at Hardwar.
I hear a yogi, Pa's devotee, tell Ganga's story:

In primal time a king named Sagar aka Full of Moisture, was
 sonless.
With his two wives he approached Sage Father for the boon of a
 son and heir.
In accordance with the part auspicious, part inauspicious time of
 the request,
Father gave one wife 60,000 sons born from her
in a pumpkin-gourd from which each seed was gestated in a ghee
 pot.

To the other wife he gave one son. "The 60,000," Father foresaw,
"are all bad seeds, unable to know right from wrong.
Their cruel deeds will arouse Son to take man form as sage Kapila.
He will burn the 60,000 with one glance.
Their ash ghosts will lie unpurified in the underworld.
The other one son will be cruel. You will send him into exile.
That son's son, your grandson Ansumat aka Juiceful, will be wise
 and good.
His grandson will redeem your unpurified lineage from the
 underworld
by arousing Mother's grace to come as Ganga and wash the
 departed ones."

What Father foresaw happened in the course of time.
King Sagar sent his sons with a sacrificial stallion to roam the
 earth.
The custom was for such a horse to cover a king's territories and
 then return
to be divided in a rite apportioning the king's world.
The horse disappeared into the basin of a dry sea. The 60,000 sons
dug deep into the sea bottom. In the north-east, they hit the way
 to the underworld.
There below was the sanctified horse grazing and Sage Kapila
 meditating.
The 60,000 ignored Kapila and ran for the horse.
They crossed Kapila's concentrated splendour and burned to a pile
 of ash.

Then King Sagar summoned his grandson Ansumat to bring his
 sanctified horse back.
Ansumat entered the sea basin and descended to the underworld.
There was the sanctified horse grazing and Sage Kapila meditating.
Ansumat bowed before Kapila. "Great Sage," he said,
"I have been sent by my grandfather to fetch this sacrificial horse."
Kapila said, "I am pleased with you, my son.
You have acted in accordance with patience, law, and truth.
 Choose two boons."

Ansumat said, "May I bring home my grandfather's stallion,
and may water purify my 60,000 uncles so that they may visit
 Heaven
though they died without the Heaven-going merit of those who
 conclude proper rituals."
"I grant you the horse, my son," replied Kapila.
"And I grant that your grandson will successfully request of Mother
to descend as the all-purifying Ganga down to Earth from Heaven
and purify the ash ghosts of your ancestors."

Ansumat's son Dilipa was a good man. Like his father, he worried
and grieved over the destiny of his 60,000 heavenless ancestral
 ghosts
but to request Ganga from Mother was not in his meditative
 power.
He retired to the woods to reach heaven through the perfection of
 austerities.
His son Bhagirath put the kingdom in order and set out for the
 Himalayas.
In the beauty of the mountains, he fasted and meditated on
 Mother Ganga for 1000 years.
In Her goddess shape She came to him. "Noble king," She said,
 "ask for a boon."
"My 60,000 ancestors lie, unpurified of their sins, in the realm of
 Death.
Devi, I beseech You to descend and wash them with Your touch of
 Heaven!"

"You must go to Sage Father's mountain peak. There meditate and
 request of Him
to catch My fall from Heaven in the dread curls of His topknot.
Otherwise My Ganga's force will destroy Earth."
Assiduously Bhagiratha obtained the desired boon from Father.
Full of roars, whirls, foam, and creatures, from minnows to
 crocodiles,
Mother came down in a great plunge from Heaven to Earth

through Pa's topknot.

Bhagiratha showed Her the path from the mountains to the dry sea bed

and the underworld descending from its north-east corner.

In the Death realm She washed the ash bodies of his ancestors.

When the yogi on Ganga's ghat completed Ganga's story, I protested,

"But yogiji, how does your story solve our problem?

Though She carries the *OM* and wash of Heaven, Ganga Earthly and inner

is dammed and polluted by us.

Like the 60,000 sons, our ancestral and past deeds have dug down to Death

without honouring the sage Son manifest in meditation there.

Though Ganga within us purifies within us,

the ghosts of Death seep up from below us.

How shall we rectify the error and ignorance we terribly contain and inherit?

Must we not request of Ma, Pa, and Son a new miracle for our time?"

Yogiji says, "Miraculous acts are timeless and timely.

Listen to Ganga and you will understand this.

Her waters pass quickly with great force.

Stay by them, practise yoga, be austere, be touched by the wonder, bring flowers.

The timely timeless Ones make times to act, times to listen, times to sing.

They manifest now conspicuously, now obscurely.

Through love of Ganga, within or without, Their truth is remembered

and truth's deathless mortally-struggling future is to be found.

"Hear also the hidden book of Son manifest as Sage Kapila devotee of gnomic Pa

meditating in the underworld of Death:

'The endless end of immortal souls, as of Me, is the endless non-
 return
of pains and difficulties.
Immortal souls exist in combination, perception, and enjoyment of
 one another,
in singularity and in freedom.
Ma's birthing of immortal souls, as of Me, is in bliss and vision.
Reckon how to daily endlessly suffer pains and difficulties in
 catharsis
for souls in their embodiments whilst remembering bliss.'"

Having delivered his wisdoms, narrative, devotional, ethical, and
 metaphysical,
yogiji's heart and breath cease to flow his life rivers through his
 embodiment.
His devotees burn his dead form in a pyre on the river-*ghat*.
We gather his ash ghost in a pot and put it in Ganga and She takes
 it
while his light form dips in Her with us though we grieve and offer
 tender tears.

IX. Pa Carries on

Pa says, "Grieving ones, journey with me to the immaterial shore
to which souls go, whence their new births come to this Earth
 shore.
Among Great Souls returned to non-birth, yogiji rests beyond with
 the Self-borns.
Beyond that beyond is the ecstasy you are seeking and the end of
 your questions.
To these realms of disincarnation, I am your guide,
as Ma guides you in incarnation."

We cross the waters and enter the fields of departed souls.
In their various shades of red, blue, and yellow, also white and
 brown
and all mixtures, having journeyed in Pa's white boat
in shapes smaller than a candle flame, they bloom as into lotus
 buds
adrift in a subtle breeze.

Here is a wind of souls rushing to be rashly reborn in the Kaliyug.

Here are the tangled sworls of those departed in confusion
their soul-knots loosening
as they lay their bewildered heads and breasts
each on Ma's laps multiplied for them.
Her hands, multiplied for them, smooth their thoughts
as a mother deftly untangles a child's hair.

Here are Ma's helpers, the souls already healed by Her.

Here are those leaving their souls on Her lap
and journeying with Pa to the brief ecstasy where He is light and
 all is clear.

Here are the souls of those who died following the Age of Slow in
 the Age of Fast.
No longer pressed by worldly time, they sit with Ma in Her
 peaceful cave
and with the Mothers in Their cave,
and the Mothers bring them flowers from Their green fields.
And here among them is my husband's soul
and he says to me,
"Hang in there on Earth. Speak of the Age of Slow in the Age of
 Fast."

Then there comes a buzz and swarm of the souls of the
 perpetrators of the Age of Fast
clamouring for rebirth with more power than they ever had before.
So I say to Pa, "These are my enemies, the enemies of my family,
the enemies of my loved ones, the enemies of life on Earth, the
 enemies of Ma!"
And Pa says, "That's how it is." And he shows me the enemies of
 life in me,
in my quest for the power to know and to speak what I know,
and how my search is as a dot in the order of all that is.
And the dot burns away beyond the other side of what I can know
 and say.

Then Ma tells me with an adoring sigh,
"Pa is My truest illusion."

X. Ma Teaches Her Small Cosmos Long Path

We who are grieving are not consoled.
Dolphins, whales, songbirds, furry mammals, fish, serpents, bugs,
crystals, stones, trees, flowers, mountains, clouds, rivers, lakes,
Santals, Bhils, Gonds, Bonda, shamans, aborigines, *tantrikas*,
Chantway hearers, balladeers, bards, healers, mourners, lovers,
Inuit, gypsies, Bauls, Bhaktas, Lakota, Dagara, Yoruba,
Sufis, Celts, Kogi, Zuni, Sagay, Wandjina, Maradudjara,
Chukshee, Huichol, Jivaro, Salish, Dogrib, Amahuaca,
peoples whose languages are dying, creatures whose sounds are rare,
beauty-lovers singing mystic, beings old and new,
souls cry between Earth and Sky:
"Do not abandon us, our Beauty.
Do not abandon us, our Love.
Do not abandon us, our Wonder."

Hearing our cries so manifold and pitiful,
Ma Self-multiplies Her voice on Earth:

"Woman in Man! Awake!
Your energy is truly half of all! Awake in women and awake in
 men!
Drive back too much excess of male in all!
I hereby arouse rebalancing for life on Earth!"

There sprout Mother vibes, Her creatures, Her men, Her saints,
 Her gurus.
I hear Her through one voice, others through another voice:
"My children, love My Earth, love one another, love Truth as One.
You are born of Me. My Love is One. Live moderately. Seek
 wisdom.
Abjure greed. Know, your excesses will be self-destroyed.

"You have heard My big cosmic tale, how incarnations came to be
 from Me.

Picture My reproduction in Your small cosmos:
Your own subtlest inner Buddhi, your Conceiving Mind, is My first
 daughter!
She is My Word-Maker, My Vision-Maker,
My bright mirror. She sees what comes and goes.
In Her breeds your I-seed, your separable self-conceiver.
From your I-seed out-sprout your energies, dauntable and
 formidable.
Then take flower therein your subtle organs, entirely suggestible.
Then fruit your subtle elements, all connectible:
Space, Wind, Fire, Water, and the last is Earth most groundable.
Then is born on Earth, in your body composed of gross organs and
 gross elements,
your *jiva*, your incarnate soul.

"In the course of many lives, body birth after body birth, life by life,
in the course of one life, year by year, day by day,
a *jiva* sees through her layers to her Buddhi seed.
When her education is perfected, infolding and unfolding,
she teaches the Buddhi path according to the need of each.
To the austere knowers, she gives austere knowing,
to the austere doers, austere doing.
To those too pitiful to follow those paths so arduous, she gives love,
she gives stories of her paths, she redeems by love alone.
Not yet is this your story.

"Ironbiter, your present incarnation approaches its third stage of
 life.
It begins to let go its material properties.
Your vigour is more slow to fight.
Your powers of conception shift from gross to fine.
You foresee your body going.
In its dreams your *jiva* considers its past course and its next birth.
Still you are restless and shun peace of mind.

"Undertake My most austere illusion.

Like Pa and His linga, know yourself by going in.
On the other side of each self-provocation
there is an Abode untouched by war and time.
There is no desire, no urge to birth, no play of two, no vital fervour,
no words, no you to tell of It, no illusion of any kind,
complete freedom, no need to restrain yourself.
With Pa as guide and half-progenitor of All, you know It.
Every night in deep sleep, dreamless, you taste It.
Say a mantra, and point your mind toward It. Let your words go.
Let My myths go.
Be patient. Breathe slowly.
Do this practice at dawns and dusks.
Shine your bodied Buddhi."

PARAVAC
Secret Voice

I. The Song Mothers

Instructed by Mother Divine to retrace in my embodied mind
my evolution from Buddhi to *jiva* back to shine,
I see washed in Her river Father's unborn face where no marks are,
a stone smooth and rose-brown in lingam shape
marked with the mantra *OM* carrying His breath of life always,
and I see shining in Her mindstream a crystal the size of a digit,
 lingam
of Father's Divine Person Purusha Who lives in each heart's centre,
His city, His mountain cave, His wilderness and His garden.
Within that inscrutable space, Purusha in heart-mind, there speak
the origins of me in the deathless shine.

Instructed by Mother, I sprinkle Father's icons,
the stone on my puja table, the crystal in my heart,
the cosmic lingam, the heart jewel *hrdamani*,
the eternal obscurity, the eternal refraction,
the mystic seeds planted in me as in all *jivas* and all things.

Then before my eyes Love's shape sprouts forth shining.
Facets of the jewel in my heart unfold cosmos, world, and me in
 one vision.
Then again, the lingam subsides faceless, facetless, far away, in
 sacred seclusion,
leaving dark clouds from which falls grief, from which bolts
longing,
 my stormy world, my stormy heart.

As a male cobra unfolds his scarlet lingam into the long and secret
 interior
of the cobra female who has slowly given way to entwine with him,
 then glides off
for a year like forever, His Otherness went off.

I cry for His Love to be born again,
for His form to appear near in another,
for His shape not to forsake human form.

"Harness your grief, Suzanne," says Mother.
"Hear secret ways to draw Him near from far.

"Inside and out, moods oscillate.
Behold, love's mood—in two extremes it comes and goes.
Yours once was bliss and now it's anguish.
And so, in the course of moods,
a different oft-told tale begins again.
As in courtly days, in mystical romances,
when passions burned down scarlet to a purer glow of white or
 gold,
Love's pain and ecstasy live, turn by turn, in His devoted servants.

"Learn from Meera, your sister of old through whom
I sing to My Beloved Lord, My Other One:
'Do not abandon me, Jogi, do not abandon me.'"

Jogi is Meera's name for the One with Whom she must be one.
 He is
Krishna, her husband. For love of Him, she rejected her human
 husband.
She gave up all other pleasures to serve Him.
As man and wife are one flesh, she and He are joined.
If she can't find Him, she is torn in two and she will die of grief.
She seeks with her inner eye, with the inmost touch of her skin,
within the inmost spaces where her breath is.

The fleshly body of my husband burned away.
Not yet is my flesh burned away, nor is it gone.
Not yet has it stopped looking for an other in touch outside me.
Meera says, "There is joy. There is pain."

In all the world, no one, no thing can satisfy the pain of longing
except the One, the Jogi with Whom she must be one beyond this
 world too.

Singing, she arouses her faith from the anguish of separation:
"I see my Lord in the middle of the night
in the dark woods on the banks of love's river."

"And now," says Mother, "learn this concentration of your heart;
sustain by this focused Meera song one imaging of all your wishes:

Live in my eyes, Beloved. Enchant me with Your night-dark form.
A garland of marigolds, gold bells on Your waistband and anklets
cross Your body like bright stars, rays of lightning in black cloud.
Pour into my ears the deathless nectar You blow through Your beguiling
 flute.
I live and suffer pain so that You will come where I am.
Even for a moment, be one with me.
If I had never tasted the bliss of Your presence,
I would not feel this anguish. As it is,
how can I bear our separation?
Meera's Lord is of the high mountains and deep seas.
Live in my eyes, Beloved. Enchant me with Your night-dark form.

Mother, my heart is not relaxed.
My mind is not single, but restless to be gratified with bliss and
 freed from pain.
The Visitor I seek, my Otherness, my Truth-bearer, is not with me.
The place is empty where once He was. I am scattered in search of
 Him.
Everywhere I turn, empty of Him is that place.

"Abandon yourself," says Mother, "to the obstacle-dissolving moods
of Meera's ragas, as they loosen by vibration the hollows of your
 heart and lungs,

the cells of your tissues,
your head hollows, your belly hollows.
"Do this practice every day for one hour at dawn or dusk.
As my bhaktas, Sufis, bees, chanters, and singers of all kinds loosen
 and intertwine
the mixed flows in their bodies singly or together, try this.
Do the practice that purifies the heart.
Do the practice that releases the heart's storm.
Abandon yourself to Meera's love-in-anguish song:

My Lord, no one understands my pain. My heart burns with love for
 You.
No one understands. Meera burns for You alone.
Someone wounded knows a wound's hurt.
A jeweller knows a jewel's worth.
No one understands my pain as I burn for You alone.
How can I serve You as I lie in anguish?
How can You, Whose bed is the circle of the universe,
come near my shameful bed?
My Lord, no one understands my pain. I burn for You alone.
No herbs relieve this suffering. I roam from home through the dark
 woods seeking You.
If You were where I am, I would be healed.
Dark Lord, understand Meera's pain. I burn for You alone.

"This is the practice that purifies the heart.
This is the practice that sanctions all scattered longings.
It is as it is. It feels as it feels."

Mother through Meera sings on, her desire showing more bold:

Dark Lord, where is Your flute of hollowed reed,
Your drum of hollowed bole?
Awake, Dear Love!
Dawn comes!
Doors open!

Girls churn curd,
their bracelets ring!
Get up, Dear Love!
God-forms show,
boys play with butter,
cows low.
Awake, Dear Love,
take Meera in.
Awake, Dear Love, awake!

No wind,
His breath in the reed's hollow
and the soft pulse of His drum
and His dancing feet.
He is awakened!

The spine is His reed.
His breath pierces
from the root to the opening.

The spine is the staff of the ektar-string whereon vibrate the
 overtones
when He arouses
her voice in her navel and breast
to echo His breath.
Meera is His goddess voice, she is His goddess of connection,
she is a bridge of love
built of wave lengths and textures.
He tunes her all the way from her lowest fret
to the yogini of her mind sitting in her head-cave at the peak of
 her body mountain.
He arouses her attention.
He gives her heart connection, lest she isolate herself from the
 ongoing world.

Long ago,

among the primal yogis and yoginis, the ethereal proto-sages and
 the wisdom mothers,
Meera sat in inmost meditation in the mind fields of the Birthless
 Sage
Who is Other because He can entirely distinguish Birthless seeing
 and hearing
from the interactive fluctuations of born minds.
By their inmost hums, the yogis wished to quest,
and they quested in their hollow places,
and His Otherness beat out for them the seeds of thoughts subject
 to their life cycles,
and He breathed out the undulations interwaving their minds and
 mind.
Some yoginis became Wisdom Mothers of Incarnate Sons,
some became Wisdom Mothers of Incarnate Sayings, and some, of
 Incarnate Songs.
Thus from their hearts, from their navels, from their bodies,
sister Meera and the Song Mothers vibrate
secret energies of goddess Voice, Devi Paravac, as She moves
on the swan wings of Deathless Soul, full-feathered by all
 Deathless Souls,
in the breath-stream of the Birthless Sage.
Voice Devi says, "Give way to this swan journey and this stream."

II. The Four Teats of the Vac Cow

Of Voice Devi's secret nourishing of all journeying soul-swans,
Her Incarnate Sayings esoterically picture this metaphor:
Milk gathers in the four teats of Her complete udder. The teats
 carry
waking, dreaming sleep, dreamless sleep, and the witness, all-seer,
 connector.
A little milk moves through the first, a little more through the
 second,
through the third even more, and through the fourth, as through a
 fountain
milk pours until the drinker of Vac no longer distinguishes one teat
 from the other,
no longer distinguishes Her milk from herself or Her.

Manifoldly quatrifold are the correspondences of the secret image
 of the Vac Cow,
the gentle weaponless bodacious mammarian Vac Cow,
the Vac Cow mooing freely in Her fields of greens and flowers of
 all colours
in the image of Her Incarnate Saying.
The sounds of the teats are: *A* the all,
U the lustre, *M* the wisdom, *mmmm* the resonant reverberance in
 all hollows
that brings endless variations together in endless *OM*,
the sacred soma-shimmering mantra-milk of the Vac Cow.
For one who drinks fully from the four teats of this *OM*-making
 Cow,
there is no fear. So tells me Her proto-Tantric philosopher
 Gaudapada
three half-millennia ago, commenting in 215 verses on the Saying
 of the seer Mandukya
which in twelve passages is, some say, the most condensed
 distillation

of those wisdoms the Vedic sages drank directly of old
in the Himalayan ashrams from all the four Vac teats, the art of
 which drinking they say
is to be found continuous in the *OM* practice generated in Devi's
 womb without end.

Seeking diplomacy with *OM*-less neo-sages who loudly fear
 regression
into the womb or the dreamy, creamy, unmeasurable, primordial
 milk ocean,
Gaudapada argues that any immature or regressed self is
 impermanent,
as is any self abjuring the womb or the fourth teat:
the self of the waking teat disappears in the draught of the
 dreaming teat,
the self of the dreaming teat disappears in the draught of the
 dreamless teat,
the witness observes all.

The times of the teats lead from the impermanent to the
 permanent: *A* the past,
U the present, *M* the future, and *mmmm* beyond all parts of time.
The aspects of the teats lead from parts to whole: *A* the terrible, the
 physical cosmos;
U the universal mind, the womb of light; *M* the creator, the first
 cause;
mmmm the unlimited Self of All.
The life-stages of the teats are for learning, householding, forest-
 dwelling, solitude.
The flows of the teats are the four rivers of paradise,
their protuberances the four mountains,
their directions the four quarters of earth and sky
filled with the milk and subtle *OM* of life
in which *AU* is want and pain, and *Mmmmm* is calm healing.

If I ceased thinking or drinking the whole draught, would the

healing dry and die
and my soul-swan stop journeying?
It is a sin to kill the sacred cow.
It is a sin to make a cow of gold.
It is a blessing to feed the cow at dawn, follow her to pasture,
 return with her at dusk.
In lieu of cow, for exchanges of nourishment
anything can serve, anything can be substituted.
These are the always-adaptable multiple correspondences of the
 mystical Vac Cow
of Which I speak as in the ancient days and every day nursing new
 births.
When the wise Buddhists drink from Her they name the teats
Buddha, Sangha, Dharma, and Nirvana is the fourth.
When the wise Christians drink from Her they name the teats
God of Power, God of the Word, God of Love, and God's
 Kingdom is the fourth.
And others of all kinds give the Four each their own names.

Why should I wish to insist there is goodness not to be lost in
 regressively
Esoterically, contemplating Vac as a Four-Teated One-Uddered
 Cow if it were not that
as a choice-driven human with a journeying swan soul I have and
 offer,
among my manifold and prevailing doublefolds,
two hemispheres, two hands, two feet, two breasts and two nipples,
 and from such twos
I think and drink and transmit to my children, to the future,
a potion of a binaritude that likes to prefer one side to the other,
that conflicts one to the other. Vac Devi says to this,
"Not to worry. One is good, and the other is good,
and good are the four teats within the udder round,
and good is the milk in its flowings four,
and two times two is four, and journey on, swan."

162

III. Spanda in My Vac Veins

Of the sacred herbs of poppy and coca, tobacco and hemp-weed,
their umbilicals I cut without ritual of reciprocation from Mother's
 body,

of Her sacred jewels of quartz, emerald, ruby, sapphire, and
 diamond,
their umbilicals I cut without ritual of reciprocation from Her
 body,

of Her sacred dreamers and spirit travellers and guides,
their umbilicals I cut without ritual of giving and receiving from
 Her body,
their dead images I rotely replicate,

of such things I broke and break, this is not now the story.
Of how they drip in my breath-stream a weight of sorrow this is
 now the story.
For around this burden the nerves of my body-forms tighten,
the sinews of my body-forms strain with a great strain,
the flows between my body-forms find no place to be.
Life loses ground in me.

Pondering this sorrow three half-millenia ago
(closer than me to the ancient seers who drank most direct from
 Voice's teats,
yet pondering like me with self-conflicted two-breasted bicameral-
 brained body form),
Gaudapada finds a merely apparent doubleness between sorrow
 and milk-bliss.
In the floodtide of our history, he says, our desecrations churn us all
 in a great sorrow sea.
From this there is freedom in *spanda*, a shimmering, pulsing, non-
 churning vibration,

always in us. It is, he says, Swan's deathless heart.
Spanda makes rays of splendour shimmer through the *OM* milk.
Spanda's expansion out-scrolls unmanifest, fine, medium, and gross
 doings.
The vibration in our consciousness appears to heave and be
 separated.
To us parts appear cut apart and dispersing.
But the shimmering does not heave, it does not separate.
It flashes, and everything is radiated as on the first day.

The *spanda* of Voice, Word, Truth flashes inside my body-forms.
It moves in fine degree with the *OM* milk,
is given birth through my mouth, my hand,
reminds my journeying soul of the splendour holding awakening,
 dreaming, deep sleep,
reminds me of the watching.

Voice's proto-Tantric grammarian Bhartrhari, Her Gaudapa's
 contemporary,
compares *spanda* to a peacock's egg, slow and inward,
holding in seed all its colours, unscrolling as life unfolds in all and
 each.
Before milk flows to us, before each of our beginnings, is union of
 egg and seed.
Says Bhartrhari, "Sound seeds Buddhi. Voice conceives Herself.
She is vibrant. Adore Her birth!"

This is the secret teaching of Bhartrhari, Her grammarian:
Into my body-forms self-desecrated and churning in my great
 sorrow sea
Voice bears my conscious light.
For the sake of making meaning, for the sake of connecting fine to
 gross, in to out,
Voice is born in every form, in me, in you.
For freedom in the great sorrow sea,
each born voice, each journeying swan,

remembers the shimmering vibration from whence it was born
 free.
My soul-swan has the womb, and my *buddhi* is the womb
clear and pure, where Vac Devi flashes Her pulsing seed.
The *buddhi*-womb swells with a universe of sound
in which everything is connected and all twos interflow.

This is his grammar of the Vac cow:
the waking state is Vac in the third person, she to he, he to she,
 they to they,
dreaming sleep is Vac in the second person, soul to soul, thou to
 you, you to thou,
dreamless sleep is Vac in the first person, self alone, I to I,
the witness is every voice coiled as one, as in a peacock's egg.
Vac in the first person seeks conversations with you, thou, we, she,
 he, they.
She seeks second and third persons.
She speaks truly seeking them.
As a peacock by outer tail, She displays by inner tale
secretly flashing in Her *OM* udder.

Thus testifies Her grammarian milk-drinker Bhartrhari.
This Bhartrhari, or a same-named poet more *OM*-less, testifies
of sad-taled flashless churning in life's sorrow sea:
"I tasted no pleasure, and I am consumed.
I practised no penance, and I am afflicted.
I did not escape time, and I am pursued.
I did not shrink desires, and I am wizened.

"To be worldly, to be austere—
in the haste of my living, I tried both and completed neither."

IV. Refinement of Rapture

Voice arouses Her philosopher of poetry
Abhinavagupta, analyst of moods from sad to glad, master tantric
 of Kashmir.
In books a millenium old, he tells me of eight passions which are
the traditional feeling-flavours of our human tragicomedy
 according to Indian theatre.
To love, laughter, compassion, fury, valour, terror, loathing, and
 marvel,
he adds a philosophical passion, peace.

These nine passions, he says, originally coil as One in Lord
 Deathless Swan's heart,
in the deathless core of each swan's heart, the centre of each swan's
 journey,
in my journey. Outscrolling in us, they churn our churning, create
 our creating,
connect us Heart to heart to heart.

Poetry, he says, concentrates our churned minds.
It carries us on a conscious raft of remembering.
It distils from our changing moods a flash of their birth in power.
We feel the original *spanda* from whence all movings move.
Our passions stir Heart to heart to heart.

The mix of nine passions shifts among three vital qualities: moist,
 hot, dry.
The qualities combine in five mouth-tastes: sharp, bitter, sweet, salt,
 pungent.
They aromatize our excreta such as sweat, breath, urine, dung,
 looks, words.
There recollects in the brain's ancient stem its experience of
 repeated scents.
From continuity slowly wrought there increases awareness.

From awareness comes complexity. From complexity comes refinement.
From refinement comes elegance of understanding.
From inelegance comes conflict of mind and body, loss of love and peace.
Says Abhinavagupta,
"The *spanda* vibration impassions my heart.
I experience my complexity.
Spanda purifies the pain it gives.
Then comes a touch of the Lord's breath. I melt away.
From the struggle of my churning, I am released by love into union, into blissful peace."

Secret is the love tremor of Abhinavagupta. Secret is the rapture.
Secret the way a mortal mind churning its pain,
churning its ignorance and its violence,
touches immortal nectar, deathless healing.

There is a legend told of swans
that they separate milk from dark water in the lake of mind
which is called Manasarovar in the Himalayan mandala under Mount Kailas,
which is Earth's snow jewel in Her lotus valley.
OM MANI PADME HUM is Her mantra of this mandala:
in My lotus, My jewel.
Kailas is the centre of Her swans' complete circling.
Of their earthly mandala, it is *hrdamani*, the purified heart jewel.
Their songs fly past earth, water, fire, and air,
through which elements Durga, Prajna, Shakti, and Mother lead me
poetizing in jagged voice much borrowed.
They fly me still jagged, still patched in borrowed bits,
to the inmost upmost edge of ether, Voice's sphere,
to the periphery of the Other Eye.

MANI
The Jewel

I. Like a Meteor

Here continues my search on a path heaped with snow and ice.
Here are seers, their peace self-born, refined, not born from my
 mind
which bears as a mother this body and this world.

The shadow of a seer approaches like a spirit meteor,
full of refined elements, whose density of enduring truth
is composed entirely without weight of matter.
Thus is he called guru, a heavy one, though of dense body,
of past thoughts, deeds, and words, of such karmic loads, he is free.
Condensed in a point of conscious light, he descends slowly from a
 distant cave.
He is a jewel saddled on the back above the heart of an *asva*, a
 horse to be sacrificed.

I remember this horse. Once she was my mare, my mate.
I was as the male moon, she the woman sun, pelt of gold.
The sea was her stable. There she was born, making the sea white-
 maned.
Every year she journeyed to a cave in ice-crystal mountains.
Every year she descended. Every year she was sacrificed.
Every year she was returned to her stable in the sea. There she was
 reborn.

She and all animals are in every mind descended from animals.
They saw the world before man. To him they pass the seed of what
 shall come after.

She is the mortal cycle in things that breathe and bleed.
She carries on her back the cycle of the sun's day.
She moves the centre of the sky bodies. On her shortest day, her
 sacrifice renews her.
It binds fire and blood, sky body and flesh body, vehicle and

traveller,
metaphor and mind. The ritual is an initiation, its symbols most
 secret.
Eros, embodied love, comes before it.
After we penetrate one another, after I put myself in her,
she carries me toward her death. Her heaviness is me.
What is this interpenetration? What is this carrying?

II. The Horse Ritual

To answer these questions
I stop beside the path and sit to recollect a timeless time now and
 long ago.

I am in the mystic horse. Her shape comes over me. Like her four
 feet,
the liturgy has four paired lines. A seer asks:

"Where are earth's bounds,
where is earth's navel,
of the horse to be sacrificed, where is her pressed seed poured,
of speech, where is heaven's high bridge?"

A seer answers:
"This altar marks earth's bounds,
this worship marks earth's navel,
soma libation is the pressed seed poured,
prayer is the high bridge."

Guru says:
"Your body, sitting, is the ritual seat,
your mind, focused, is the worship worshipping,
your breath, timed, is the libation pressing in and out,
your chant, tuned, is the prayer praying.

"In the sacrifice of the mare, time dies.
In the ritual pause, through full moon past spring equinox,
every part of her shows its symbol, nothing is left out, every symbol
 is its counterpart,
no act marches in time to the day to come, every deed stays where
 it is.
Of the vehicle of all going, this is the renewal."

III. Reordering

The moon does not rise at the hour I expected.
How can it not rise? Where is it? There are no clouds.
It is the hour. I look, and I look again.
It is all changed.

A voice sounds:
"Oh hard-journeying human woman,
return the horse with the jewel and your quest to the deep sea,
return the horse with the jewel and your quest to the deep sea,
return the horse with the jewel and your quest to the deep sea.

"This act ends an end and begins a beginning.

"Do this to the seventh generation, of which you are the middle
 generation.
When your great-grandchildren rebirth your great grandparents,
let them give this most ancient wisdom renewed,
let them speak of the mothers' jewel
stored in deep places."

PADMA
One Lotus, Many Petals

I, Mother Dr. Prof. Mrs. Ms. Suzanne Ironbiter journeying swan,
make this prayer:

As glimpses of the divine presence have a thousand thousand
names in Sanskrit and how many more elsewhere in all the
languages of all the worlds,
 and as to each living being there is given a glimpse and a
 name
 to be honoured among all others,

and as sages of all lands behold the divine light of Wisdom and
variously remind us to seek it, wherein
 some tell us God was born as a human to show light in
 dark times,
 some proclaim God spoke through His prophets of faith,
 law, and justice,
 some say Buddhas and Bodhisattvas, having awakened their
 minds, manifest Truth for us in compassion,
 some apply medicines nature gives us and them,
 some question us,
 some surprise us,

and as poets in every language, hearing each from their muse, sing
to us variously
 that love moves the sun and higher stars,
 that the eternal feminine moves us on,
 that the heart stands still with delight gazing into the eyes
 of Life,
 that God calms Eve, mother of our human race, her spirits
 discomposed,
 with gentle dreams portending good,
 that when we arrive where we started we know the place for
 the first time,
 that there are endless streams from the song and story sea,

and as mandalas appear from of old in mystic showings by myriads

wherein

> some perceive the symbolic correspondence of four quarters,
> some bear a cross,
> some feel immortal souls caught in the web of life and
> death,
> some sing the mystery of two as one,
> some hear the *OM* of the true Self vibrating the thousand
> petals of energy at the head's crown,
> some envision a seal engraved with one's own name and set
> in bezels formed by each person awakening,

so may we each glimpse and awaken in our own way.

OM
OM SHANTIH
OM **PEACE**

Appendix

ABOUT THE SOURCES OF THE POEM

The Devi

The goddess is one of the oldest continuously worshipped deities in the religions of the world. Her forms embody the cyclical rhythms of birth, life, and death that underlie the evolution and development of consciousness. In prehistoric sculptures, her relationship to the conscious and directional forces in life was expressed in the androgynous form of a heavy-hipped goddess with a long upward-thrusting ithyphallic head and neck; this phallic part of herself sometimes took the separable form of a consort. *Devi* is an exploration of the goddess in her evolving Indian manifestations.

The survival of the goddess in India reveals the continuing influence of tribal and village peoples in the formation of Indian culture. Her religion is the religion of these peoples, who live close to the earth and to the basic facts of life. They survived repeated dominations by transient invaders—Aryans, Greeks, Muslims, English—whose values were patriarchal, military and authoritarian.

In prehistoric Europe and the ancient Near East, as well as in India, Neolithic peoples, as early as the seventh millennium B.C., left stone figures of full-bodied women, their surfaces often labyrinthine, undulant, jewelled, and serpentine. All these peoples were invaded, in waves lasting into the second millennium B.C.E., by tribes whose priests and poets hymned the glories of strong sky-riding warrior gods, under whose power they slew or conquered the peoples of the old religion. In India the suppressed peoples and their female images resurfaced. By the third century C.E., during

the Gupta age, Sanskrit poets were praising a goddess whom the gods called forth when they found that they themselves could not solve the problems of life in the world.

From her ancient beginnings until now, the goddess has developed into a figure of increasing complexity. The worship traditions of tribes-people merged with the visions of poets, mystics, and artists to become a great stream. Now the power of this goddess is enormous. According to N.N. Bhattacharyya, in his *History of Shakta Religion* (1973), "nowhere in the religious history of the world do we come across such a completely female-oriented system as in the goddess-worship preserved and developed during the medieval period and practised in India today."

In contrast to the sky imagery common to poetic accounts of the invader gods, Homeric, Near Eastern, and Vedic, the goddess' images derive from her concrete and immediate presence as matter, mind, and the life in mind and matter. In these images, for example, she is called dark (Kali), hard to reach (Durga), liquid and nourishing (the river Ganga, and the names of all rivers and all waters), irrational (Chamunda, "stomach body"), circular and cyclical (Kundalini), the life force (Shakti).

The worship of deities in India, going back to old tribal and village forms, displays the radical link between physical and spiritual experience perpetuated in those forms. For example, when a person visits a particular statue, stone, or picture of the Devi, whether at a shrine, a temple, or at home, he brings her some present—flowers, leaves, fruits, incense—which he puts before her, or red powder (vermilion or *kumkum*, red saffron), which he smears on her forehead. The act of worship, called *puja*, literally means smearing. In one salutation, the *Lalita Sahasranama*, he greets her by one thousand names, and gives one gift, such as a leaf or petal,

for each name; at the same time he touches his own body in one thousand places and says one thousand times, "*namo 'stu te*, I salute you by taking your name." The Devi in turn gives him *darshan*, a "look" at her one thousand powers inside himself. Her shrines or "seats," all over India, all point inside the individual worshipper.

In the knothole of an old tree in Varanasi, Mother, the knothole goddess, can be seen in the form of a silver face. There is an Indian saying, "Where the hand goes, the eye goes; where the eye goes, the mind goes." With his hand a person rubs *kumkum* on that Mother, his eye sees her face; his mind goes where she is, which is inside him. His internal body, his self, becomes the stage on which he reviews the stories of her power. If he is an ecstatic healer, he might, to release the goddess power from his body, act out one of her stories: he might prick his tongue and let it hang down bright red with blood like the goddess Kali's; then the Kali power in the healer gives the client *darshan* and destroys the demons of sickness for him.

Everywhere, in each life and in all life's experiences, the goddess is said to give people a "look" at her power as it manifests itself in an endless variety of specific forms.

Durga

The *Devi Mahatmya*, of which the *Durga* section of *Devi* is an adaptation, is the earliest and most popular of the Sanskrit poems displaying the goddess' power. Dated sometime between the third and sixth centuries C.E., it is a thirteen-chapter section (chapters 81-93) of the *Markandeya Purana*. Because it has seven hundred mantra verses, it is also called the *Durga Saptashati*

(Durga 700). It is available in Sanskrit with an English translation, in the Ramakrishna Math edition by Swami Jagadiswarananda (1971).

The Puranas are a class of sacred works containing old tales and legends (the word *purana* means old), compiled, according to tradition, by the poet Vyasa, "Compiler," a mythical sage and author to whom many Sanskrit compilations, including the Vedas and Mahabharata, are also ascribed. This process of literary production, involving anonymous composition, collection, and arrangement, allows for the preservation of a great deal of old lore.

The whole or parts of the *Mahatmya*, popularly called *Chandi*, are chanted in India as part of the worship of God as mother, especially during Durga-Puja, the four-day Bengali autumn festival to the goddess. In the poem and the worship, the goddess is invoked by a multitude of names, the chief of which are Durga (the inaccessible one), Chandi or Chandika (the angry one), Kali (the dark one), and Ambika (Mother or Woman).

According to the Bengali mystic Sri Ramakrishna (1836-1886), all forms and names are ways leading to the nameless, formless, all-pervading One, whom he worshipped as Kali. The image of Kali in a temple and his own wife dressed as the Devi were the forms through which he worshipped. Any goddess, or even any woman, is, according to the principles of Hindu spirituality, a manifestation of Durga, the unmanifest, the inaccessible.

The Devi cult was an important element in the modern Indian nationalist movement. The Bengali writer Bankim Chandra Chatterjee (1838-1894), in his novel *The Abbey of Bliss*, developed the idea of militant revolutionaries worshipping the Motherland as the Mother goddess Kali. The novel contains

a poem, *Bandemataram* (Hail to the Mother), which became throughout India the anthem of the movement against the British. The nationalist and mystic Aurobindo Ghosh (1872-1950) further developed this theme: "Mother India is not a piece of earth; she is a power, a godhead, for all nations have such a Devi, supporting their separate existence and keeping it in being." In this nationalist interpretation, the *asuras*, demons or evil spirits of various sorts from whom the goddess saves the world in the *Mahatmya*, are identified with the British, the white devils whom the goddess destroys. In more recent times, Indira Gandhi appeared as the Devi, Mother India, in her pictures and campaign slogan: "Indira is India, India is Indira."

The images of the goddess, the sequence of wars, and the names of the *asuras* in the *Durga* section are all from the *Mahatmya*. The etymologies of the *asuras'* names serve as the basis for a description of their origins. I have introduced a narrator who, as she hears the story of the Devi, has *darshan*, that is, sees her, as well as all her forms and all her enemies, come out of herself. This person's body becomes the place of the action.

Prajna

In contrast to Kali, Durga, Chandika, and Chamunda, the goddess Prajna (Wisdom), like Sarasvati, Uma, and Lakshmi, is a peaceful form of the goddess. She, like all the goddess' manifestations, displays a fecund feminine changeableness and variability. Whatever *darshan*, whatever "look" at truth she brings forth in the mind of a person at any one time, it is one of an infinite number in a whole too immense to be seen or described

completely. The word *darshan* in this context is customarily translated as "philosophy."

In the *Prajna* section, the goddess' discourse goes back and forth, like the positive and negative curves of a wave-line, between two great Sanskrit intellectual traditions. One begins with the basically monistic and idealistic teachings of the sages of the early Upanishads (eighth and seventh centuries B.C.E.), the other with the radical skepticism of the Buddha (563-483 B.C.E.). These philosophies manifest the Prajna, the Wisdom unmanifest, the truth beyond words, the goddess beyond names and forms.

Sanskrit thought assumes a direct experience of truth through the practice of sitting in meditation. The earliest recorded sages, such as Yajnavalkya and Aruni of the *Brhadaranyaka* and *Chandogya* Upanishads, teach not speculations about the universe but insights, derived from meditation, about the nature of the self and the reality within. This radically psychological focus is also the basis of later systematic intellectual positions in each of the two traditions.

As my sources in engaging with the first of these traditions, I use the thirteen principal Upanishads, and the interpretations of the Upanishadic tradition in the *sutras* of the Samkhya and Yoga systems compiled by Kapila (seventh century B.C.E.) and Patanjali (second century B.C.E.). Samkhya-Yoga is notable for its analyses of the variety of mental events in terms of ongoing evolutional, wave-like processes.

An invocation found at the beginning of several Upanishads epitomizes this philosophy:

OM. purnam adah purnam idam purnat purnam udacyate;
purnasya purnam adaya purnam evavashishyate.
(*OM.* That is full, this is full, the full proceeds from the full.

Taking the full from the full, the full alone remains.)
Here the *OM* syllable shows itself as a sound symbol of the
Upanishadic tradition of the fullness of being.

For the second tradition, I engage primarily with the *sutra*
literature associated with the Buddhist thinkers Buddhaghosa
(C.E.400) and Nagarjuna (C.E.150). Buddhaghosa compiled
Visuddhimagga, The Path of Purity, a textbook of spiritual exercises
designed to train the student to perceive everything as a succession
of momentary events, "*dharma* only." To Nagarjuna is ascribed
the definition of the Buddhist eternal bliss, *nirvana*, as emptiness
(*sunya*), the quiescence of all plurality, yet in no way to be described
in words. The most popular of the sutras traditionally attributed
to him are the thirty-eight *Prajnaparamita* or *Perfection of Wisdom*
books (C.E.100-600), among which are the *Diamond Sutra* and
the *Heart Sutra* (fourth century C.E.), the holiest texts of Chinese,
Japanese, Tibetan, and Mongolian Buddhists.

The *mantra* (sacred formula or, literally, thought-vehicle)
revealed at the end of the *Heart Sutra* epitomizes this philosophy:
 gate gate paragate parasamgate bodhi svaha
 (gone, gone, gone beyond, gone altogether beyond, mind
 awakened, *svaha*)
(*Svaha* is a Sanskrit liturgical exclamation meaning "with this
saying may there be a blessing.") In Japanese translations, the key
word *sunya* (emptiness) becomes the syllable *MU*, a sound symbol
of the *Prajnaparamita* tradition of emptiness.

The narrator of *Prajna*, in the mode of a student or disciple
of a sage or teacher, sits at the goddess' feet—*upanishad* in some
interpretations means literally to sit at someone's feet—and
experiences the varying discourse, and the restlessness of body and
mind in the posture of meditation.

Shakti

Among the popular myth cycles about the goddess Durga, one tells of her role as the wife of Shiva, the god of destruction. The stories can be found in the *Shiva*, *Kurma*, and *Linga* Puranas. The couple are said to spend thousands of years in love-play, and have to be interrupted tactfully when, as in the *Mahatmya*, divine anger and violence are needed to save the world from demons.

The *Shakta Tantra*, a class of Sanskrit texts, uses the erotic mythology of the Puranas to symbolize the experience of meditation and to picture the meditating body-mind. These texts describe esoteric practices for the worship of Durga in coitus, literal or metaphoric, with Shiva. The goddess is visualized as Power (Shakti) coiled at the base of the worshipper's spine. The texts prescribe various rituals and meditations to make Shakti rise upward and unite with Shiva at the top of the worshipper's head. There, Shakti drinks the red elixir that issues from their union, and returns to her coiled position at the base of the worshipper's spine.

The origins of Tantra, like those of other forms of goddess-worship, go back to the fertility cults of prehistoric times. Tantric texts were first written down in the early Christian era. The teachings continued to be recorded into the 19th century. Arthur Avalon (Sir John Woodroffe) edited and translated several of these texts. Because of their obscure symbolism, they are difficult to read. However, their vivid conception of the goddess as internal, and as power, connects with contemporary pictures of human energy and inherent bisexuality.

One might contrast the Tantric with other erotic mystical traditions, such as the mystical love poetry of Rumi, Dante, Goethe, or Meerabai, and the mystical interpretations of the Biblical Song of Solomon. In these conventions of mystical

love, the erotic relationship is sometimes between an idealized female symbol (the Church or the Virgin Mary, Beatrice or the eternal feminine) and the soul of the male poet; in other poets the relationship is between God, conceived as the Beloved, and the soul, conceived as feminine.

In Tantra, the relationship is between two pictures in the mind of the yogi, the male Shiva and the female Shakti, also identified as Purusha (Person) and Prakriti (Nature), or Kala (Time) and Maya (Illusion). The bliss of the union, or of the yoking between them, liberates the yogi's mind from its divisions of person and nature, consciousness and matter, and makes it one. This radical monism has a Puranic counterpart in a myth of Shiva and Shakti as Ardhanari, the androgyne. The images of copulation and androgyny combine a physiological directness, characteristic of primal fertility myths, with an intellectually sophisticated comprehension of man. According to Ajit Mookerjee and Madhu Khanna in their book *The Tantric Way* (1977), in Tantra "reality is unity, an undivisible whole. It is called *Shiva-Shakti*." It is the prolific divine mystery.

MataPita

The Tantric fecundity, linking nature and spirit, includes narrative fecundity among its aspects. In India, voluminous numbers of traditional stories are told and retold in a variety of ways long and short. They are memorized, chanted, read, depicted in sculptures and paintings, danced, sung, and dramatized on stage, on TV, and in movies.

The *Mahabharata*, the ancient Sanskrit epic of India,

fifteen times the Bible's length, is the most vast repository of these stories, collected over hundreds of years, more than two thousand years ago, and traditionally ascribed to one author, the sage poet Vyasa. It is said, "Everything in the *Mahabharata* is elsewhere. What is not there is nowhere." The epic has been dramatized as a 12-hour stage play and 6-hour video by Peter Brook, and as a 94-episode Indian TV drama by B.R.Chopra and Ravi Chopra. The other great Sanskrit epic and story repository is the *Ramayana*, ascribed to Valmiki, a poet sage. The *Ramayana* has been retold in many later Indian languages, the most popular being Tulasidasa's Hindi retelling in *Shri Ramacharitamanasa [The Holy Lake of the Acts of Rama]* (1577). Ramanand Sagar's 84-episode Hindi TV *Ramayana* honours all versions, especially Tulasidasa's.

N.N.Bhattacharyya, in *The Indian Mother Goddess* (1999), cites a late Bengali retelling, *Adbhuta Ramayana*, in which the heroine Sita, taking the form of Kali, kills Ravana, the demon enemy usually killed by her spouse Rama. Bhattacharyya says this tradition is repeated in most of the Bengali *Ramayanas*. The narrative chapters of *MataPita* similarly bring out a goddess and female side in retelling a selection of epic tales.

As might be expected, the "everything" of the epics includes philosophical discourses and conversations. The most famous instance of this is the incarnate Lord Krishna's discourse to the hero Arjuna in the *Bhagavad Gita,* a part of the *Mahabharata.* Later Tantric philosophical sutras frequently take the mock-dramatic form of conversations between Shiva and Devi, wherein He gives Her abstruse philosophical instruction during Their leisure from more epic manifestations. I have played with these esoteric lessons in *MataPita's* philosophical leisure chapters, which alternate with the narrative action chapters. The conversations

draw from Samkhya, Yoga, and Tantra texts, particularly
Isvarakrishna's *Samkhyakarika* (C.E.ca 300-500), Patanjali's *Yoga
Sutras* (ca 500-200 B.C.E.), and Ksemaraja's *Pratyabhijnahrdayam
[The Secret of Self Recognition]* (10th century C.E.). The continuity
of narrative and philosophy in *MataPita* is part of the on-going
Tantric love play between the male and female sides, Shakti and
Shiva.

Paravac

The inherent Tantric relationship energizes Indian
poetics, *hatha* yoga practices, ritual symbols, and traditional
sciences such as Ayurvedic healing, astrology, numerology, and
physiognomy. Desire "is the prime motivating force of the
universe," writes Harish Johari in *Tools for Tantra* (1986). In this
mystical perception, all aspects of life are created, empowered,
and illuminated by the dynamic of the Universal Mother's energy,
Shakti, being one in mutual desire with the Universal Father's
consciousness, Shiva.

According to Tantric psychophysiology, desiring energy
moves through our subtle inner channels (*nadis*). It cycles through
seven energy wheels (*chakras*) from the base of the spine to the
crown of the head. The seven *chakras*, with their related elemental
energies and desires, are: *muladhara* at the perineum, center of
the earth element and the desire for security; *svadhishthana* at
the genitals, centre of water and family relationship; *manipura* at
the navel, centre of fire and power; *anahata* at the heart, centre
of air and devotion; *vishuddha* at the throat, centre of ether and
awareness; *ajna* at the third eye, supra-elemental centre of peace;

sahasrara, above the crown, transcendental and all-containing bliss centre. The work of arts, sciences, and spiritual practices is to tune our natural elements and desires into complete union with our consciousness.

Inner juices (*rasas*) are aroused by our moods and passions as they interact with our aesthetic experiences—with tastes, scents, sounds, touches, shapes and colours—and with every configuration of sensory input. Indian aesthetics distinguishes nine principal *rasas*: love, laughter, compassion, fury, valour, terror, loathing, marvel, and peace. Rituals and arts intentionally arouse particular shared *rasas* in the performer or artist and the audience.

Abhinavagupta (born in Kashmir around C.E. 950) articulated the classic Indian theory of *rasas* in the context of Tantric philosophy. The foundation of our creative energy, he says, is Speech Energy (*Vac-Shakti*), Voice Supreme (*Paravac*). Natalia Isayeva, in her book *From Early Vedanta to Kashmir Shaivism: Gaudapada, Bhartrhari, and Abhinavagupta* (1995), elucidates his theory's meaningfulness for poetics and language theory. Voice "is endlessly and tirelessly persevering in its invocations and vociferations, trying to capture our attention with its own devices—the 'Voice' which is capable of convoking or evoking images, the 'Voice' that is ever intent on continuing its activity within us." Like Logos, the Word, in Christianity, Divine *Vac* is the source of revelation and the stimulus of biologically, culturally, and artistically shaped voices within the spectrum of all languages.

According to Abhinavagupta, we taste the core energy of Voice in *sringara*, erotic desire, love in separation and in union. *Sringararasa* manifests endlessly in nature, in the seasonal relationship between earth and sky, in the mating and mourning cries of birds and animals, humans among them. Popular Indian

genres arousing *sringara rasa* include devotional songs (*bhajans*), sufi mystic love songs and *filmi* human love songs (*ghazals*), ancient Vedic chants and Upanishadic mantras, and classical poetic romances (*kavya*). Among the most beloved of the devotional poets is Meerabai (1498-1547). Her *bhajans* are full of yearning for the Lord Whom she intimately pictures as Krishna. Such songs are believed to stimulate a Tantric sympathy between singer, listener, and the Divine Beloved.

Isayeva writes, "Artistic creativity is yet another simile...of the creative impulse rooted in the very origin of the universe. The initial moment of shivering tension, the moment of creative urge is bound to remain inconceivable." Poets, mystics, and metaphysical philosophers use indirect (*paroksha*) language, communicating the inexpressible through symbols, metaphors, parables, paradoxes, inversions, and ambiguities. *Paroksha* language is always erotically nuanced in the way it simultaneously conceals and suggests.

Thus the Tantric desire of awareness for experience, of Shiva for Shakti, and vice versa, of experience for awareness, Shakti for Shiva, energizes our *hamsa*, our journeying swan souls, as they seek to be able to speak our mystical mantra, *hamsa*'s inversion, "*so 'ham*, this I am."

Mani

Orthodox Hindu tradition teaches that Voice first revealed Herself to the ancient seers in the Vedic hymns, which She coordinates with ritual and mystical interpretations and their spiritual technologies. In particular traditions of interpretation and practice, Yoga meditation and Tantric ritual explicitly draw on and

internalize ancient Vedic and pre-Vedic ritual symbolism.

Contemporary scholars hypothesize that rituals of sacrifice symbolically interweave the cycles of time perceived in biological, sociopolitical, and astronomical events. In this way they sanctify and make people one with the processes whereby all things continuously and interrelatedly rise, fall, and rise again.

In *Ashvameda: The Rite and its Logic* (2002), Subhash Kak focuses on the meanings of the ancient Indian horse-sacrifice. Through metaphoric power of language, he argues, hymn and ritual symbolically weave into one experience the physical and spiritual aspects of life. "The Vedic view acknowledges that all creation is interdependent. It is asserted that *ayam atma brahma*, the Atman [Higher Self] contains the entire universe. Likewise, the body has within it all creatures. Of the principle animals conceived within the body, the horse represents time. The horse-sacrifice is then the most mystical and powerful, because it touches upon the mystery of time, which carries within it the secret of immortality. The sacrifice of the animals is the enactment of the killing of the mortal lower self for a transformation into the immortal higher self. Since the higher self cannot manifest itself without the lower one, one must settle for something less, a ritual rebirth of the individual. In other words, sacrifice deals with mastery of time." Thus Voice, symbolic structure, and human and animal form are all connected in a ritual act of redemption from time, that also sanctifies time.

Wendy Doniger, in *Women, Androgynes, and Other Mythical Beasts* (1980), recounts the history of mare myths and rituals, how the swan-necked mare sometimes takes swan form, and how the mare's spiritual function returns in myths and rituals of the gynomorphic Tantric Goddess. Doniger brings out the political and psycho-sexual implications of these historical symbolizations.

Other interpreters, like Subhash Kak, focus on a mystical continuum within the image relationships.

Tibetan Tantric Buddhism has a mystic legend of *chintamani*, the sacred mind jewel, being carried down on the horse of happiness from mystic high mountains to illumine our human consciousness in a new time. The Russian painter Nicholas Roerich (1874-1947), who travelled in the Himalayas and moved to live among them, paints this legend in *Treasure of the World*.

Padma

Padma, the lotus, is called *pankaja*, mud-born. Her beauty, opening into the light above the water's surface, is rooted in richly-decayed organic matter. She rises up from what sinks below. In the human body, each of the energy wheels is imagined as a lotus of a specific colour and number of petals, sounding a specific mantra. The crowning lotus, *sahasrara*, is pictured as one of a thousand petals opening, beyond our personal divisions and boundaries, into bliss, into a symbolic union of Shiva and Shakti, a dynamic interpenetration of above and below.

Mahayana Buddhism articulates the blissful union of experience and awareness as *nirvana* is *samsara, samsara* is *nirvana*. In the Tibetan Tantric form of Mahayana, this union, also called of Wisdom and Means, is the focus of the mantra prayer *OM MANI PADME HUM*, "In the lotus, the jewel."